Sensational SASHIKO

Japanese Appliqué and Quilting by Machine

SHARON PEDERSON

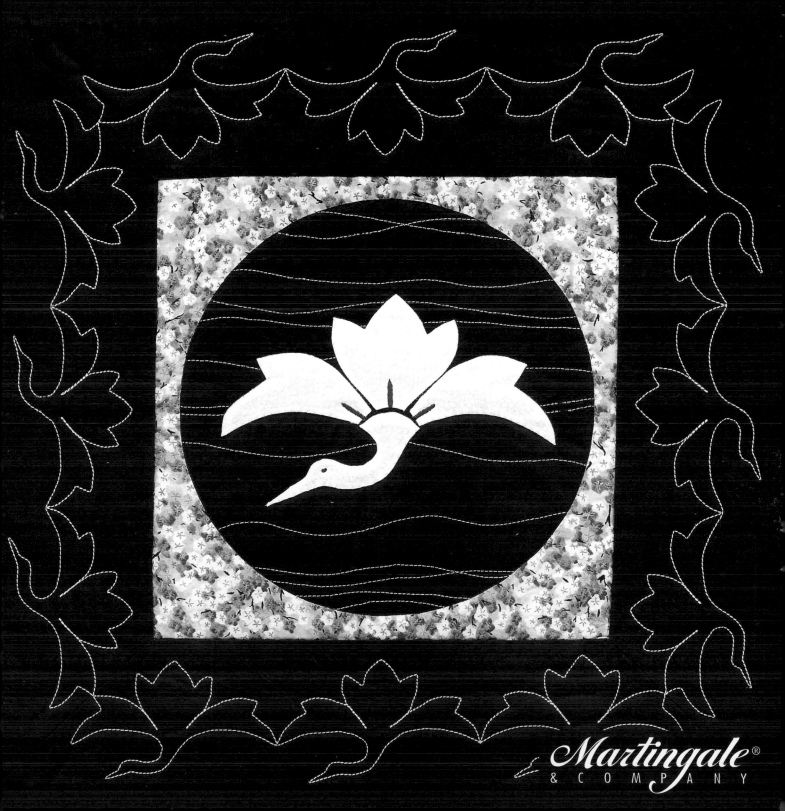

Martingale®
& COMPANY

Dedication

To the anonymous Japanese artists who created the wealth of sashiko and family-crest designs.

Acknowledgments

To have your name attached to a book is such a misleading thing. It makes it look like just one person created it when in fact many people have contributed, some whose names I will never know. I am referring to all of the anonymous artists who created the incredibly beautiful sashiko and Japanese family-crest designs. Without their amazing talent this book would not have been possible.

While it isn't possible to thank those unknown artists, it is my pleasure to thank the following:

My husband, Sy, who once again endured the many moods of a person writing a book and who expanded his cooking repertoire considerably.

My family and friends, who have encouraged and helped in so many ways.

My students, who have asked the right questions and led me down interesting paths.

The amazing staff at Martingale & Company, for their continuing help and support.

Sensational Sashiko:
Japanese Appliqué and Quilting by Machine
© 2005 by Sharon Pederson

That Patchwork Place® is an imprint
of Martingale & Company®.

Martingale & Company
20205 144th Avenue NE
Woodinville, WA 98072-8478 USA
www.martingale-pub.com

Printed in China
10 09 08 07 06 05 8 7 6 5 4 3 2 1

Library of Congress Cataloging-in-Publication Data
Pederson, Sharon.
 Sensational Sashiko : Japanese appliqué and quilting by machine / Sharon Pederson.
 p. cm.
 ISBN 1-56477-608-5
 1. Sashiko. 2. Machine quilting—Japan—Patterns.
 3. Machine appliqué—Japan—Patterns. I. Title.
 TT835.P35214 2005
 745.46—dc22

 2005008886

Mission Statement
*Dedicated to providing quality products
and service to inspire creativity.*

Credits
President: Nancy J. Martin
CEO: Daniel J. Martin
VP and General Manager: Tom Wierzbicki
Publisher: Jane Hamada
Editorial Director: Mary V. Green
Managing Editor: Tina Cook
Technical Editor: Ellen Pahl
Copy Editor: Sheila Chapman Ryan
Design Director: Stan Green
Illustrator: Laurel Strand
Cover Designer: Stan Green
Text Designer: Regina Girard
Photographer: Brent Kane

Contents

The Projects

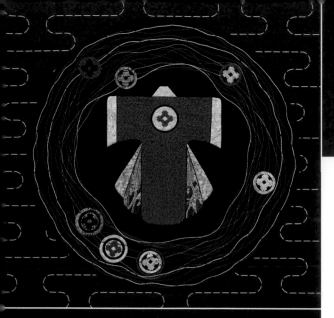

Preface

Combining two beautiful art forms—sashiko and Japanese family crests—is the focus of this book.

In the spring of 2000, I was asked to teach a machine sashiko class at a local quilt shop. Sashiko, a centuries-old Japanese stitching art, was something I had been interested in for a long time, but up to that point had done nothing about. There's nothing like a deadline to focus the mind; having agreed to teach the class, I began researching this kind of Japanese embroidery.

When researching anything Japanese, you quickly discover Japanese family crests—or *kamon*. These incredibly beautiful designs have been used in Japan for hundreds of years to identify the family a person belongs to. Quilters, always quick to recognize anything beautiful, have adopted the crests for use in appliqué and quilting designs.

Combining two beautiful art forms—sashiko and Japanese family crests—is the focus of this book. It is not intended to be a reference book for either sashiko designs or family crests. There are books already available that catalog them both. Rather, I offer suggestions on how to make it easier to incorporate the designs into your projects and make them machine friendly. My hope is that you will want to make many of the projects in this book and be inspired to move beyond the pages to create some of your own quilts using these amazing designs.

Introduction

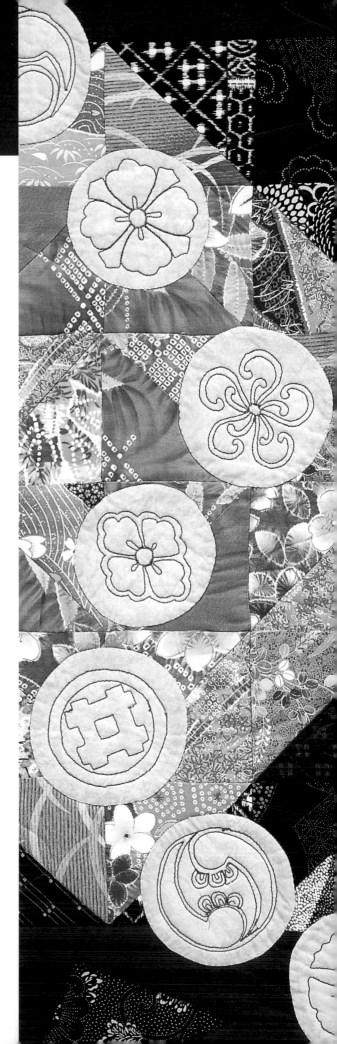

Sashiko has come a long way from its humble beginnings in fifteenth-century Japan. At a time when the type of fabric available to working people wasn't thick enough to provide the warmth needed for outdoor wear, enterprising women (I know it was women who did this) stitched many layers of fabric together using a running stitch. The word *sashiko* actually means "little stabs," which translates to the running stitch we are familiar with. The fabric used was often indigo and the thread available was heavyweight white cotton so it made a strong statement on the fabric. As women always do, they recognized that even though the embroidery was done for practical purposes, it could also be beautiful. So the art form we know as sashiko was born.

Japanese family crests, known as *kamon*, can trace their origins back to the tenth century. At the height of the feudal era, these emblems would have been found on battlefield flags, camp curtains, and coats. There are approximately 200 basic designs, but thousands of variations. Any collection of them would keep a quilter happy and inspired for years. The source books I have used are from Dover Publications; see "Resources" on page 111.

My Approach to Machine Sashiko—Reversible Method

Whenever possible, I use the reversible method of making a quilt. The typical approach to making a quilt is to first piece the blocks, then join them together, layer and baste them, and finally, quilt them. With the reversible method, you work with individual blocks, quilting them as you go. Then they are joined together with sashing.

The last steps in the traditional process, basting and quilting, are often a quilter's least favorite parts of the process. This accounts for the amazing popularity of professional long-arm quilters. Some quilters also feel trepidation when it is suggested that they drop their feed dogs—gulp—and quilt free motion. But how else are you going to sew backwards or sideways when you have something that is too big to pivot?

OK, even if you've decided to try free-motion quilting, and you've lowered the feed dogs, you still face a challenge. Sashiko requires that each stitch be exactly the same length as every other stitch (or close to it!). And there's no hiding these stitches. I'm afraid that I won't live long enough to get that good at free-motion quilting! So, how are we going to manage? Aha! We can use the reversible method and quilt one block at a time. This will allow us to pivot whenever we want to so we can have our feed dogs up and let the machine look after the stitch length for us.

My two previous books, *Reversible Quilts: Two at a Time* and *More Reversible Quilts,* demonstrate the making of a quilt that is pieced and quilted simultaneously, resulting in a reversible quilt that looks wonderful on both sides. It is my preferred method of making quilts. Many of the quilts in this book are made using the reversible technique so that you can stitch the designs easily. The quilts made with this method have a symbol to let you know that they're reversible quilts. You can choose to make yours that way or not, as you please, but I suggest that you give it a try. It doesn't matter whether your quilt is truly reversible in the end. You can use plain

fabric for the reverse side or make it as lovely as the front. Please refer to "Reversible Blocks" on page 20 to learn this wonderful, liberating technique.

To do Japanese-inspired appliqué and sashiko by machine, you'll need only the standard supplies needed for any quilting—a sewing machine, rotary-cutting tools, rulers, scissors, fabric, and thread. Read on for my comments on the essentials and some specific suggestions that will make your quilting life easier.

Fabric

Fabric choices are very subjective, but my advice is to use 100%-cotton fabric. I leave the decision to prewash or not up to you. There are strong supporters on both sides of that issue and I tend to be a bit ambivalent about it.

Most of the quilts in this book have been made using navy blue fabric—some have authentic Japanese indigo fabric in them and some have the less expensive quilt-weight cotton. You can make beautiful quilts with either or both—you can combine them in a project if you wish.

One thing I am not ambivalent about is supporting your local *independent* quilt shop. For our continuing quilting enjoyment we need local shops to stay in business, and the only way they can is with our support.

Sewing Machine and Accessories

It is not necessary to have a special sewing machine to do sashiko. All of my sashiko quilts were done on a domestic sewing machine, a Bernina 170. If your machine has the following features, your job will be much easier:

Needle-up/needle-down function. Whenever you pivot, the needle must be in the fabric so you don't end up with ½" of loose thread to deal with. I always employ the needle-down function when doing sashiko.

A knee lift. This mechanism lifts the presser foot with your knee—not your hand. It is very helpful for the many designs that require you to pivot every few stitches. Pivoting without having to let go of the block is a great benefit.

The Walking Foot

I do most of my sashiko after the quilt "sandwich" has been made, so I work with the walking foot on. A walking foot is essential. The function of the walking foot is to hold the fabric down against the throat plate of the machine while the stitch is being completed (while the needle is down), and to help move the fabric evenly through the machine while the needle is up. The feed dogs on the machine move the fabric forward or backward at a rate that you specify by the stitch length you choose. If you set the machine to do a short stitch, the feed dogs move very little; if you set it to a longer stitch, they move more. The walking foot provides a second set of feed dogs on top of the fabric that help eliminate the puckers and pleats that often occur if you try to quilt with a regular foot.

Be sure that you have a good view of your stitching line when your walking foot is attached. If your walking foot has a big metal bar that blocks your view of the needle, you can take it to your sewing-machine repairperson and have the bar ground out. Visibility is very important.

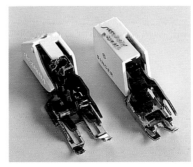

Walking feet. On the left is a Bernina foot that allows clear vision of the needle. On the right is a generic foot with a bar that obscures the needle.

The Open-Toe Embroidery Foot

I use the open-toe embroidery foot on the rare occasions when I stitch a sashiko design without batting and backing. (See "Sashiko on a Single Thickness" on page 17.) This foot gives me a clear view of the needle when stitching.

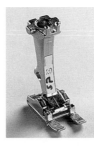

An open-toe embroidery foot

Sashiko Patterns

When I first started looking at sashiko in various books, many of the patterns appealed to me but when I looked at the illustrations, I could not see how to draft them. This is one of the most difficult things for me to figure out because I don't have the kind of brain that sees things spatially. My only option was to photocopy the illustration. I had to enlarge it, or make multiple copies and cut and paste them to obtain the size I wanted. Not a practical solution.

I know that there are lots of quilters like me out there, because I have met them in my classes many times. We're the ones who don't "see" that some patterns are tessellations. We also have trouble with angles and we probably didn't do all that well in high-school geometry. But, we are still interested in sashiko so I have figured out a few methods that avoid those situations where having a passing mark in geometry is necessary. For those of you who did get a passing mark in geometry—bear with us.

Many sashiko designs are derived from basic patterns that have been either added to or subtracted from. For instance, the very simple design called Stair Steps, with the addition of a diagonal line, becomes Arrow Feathers.

Stair Steps

Arrow Feathers

Similarly, the very popular Seven Treasures of Buddha (a pattern quilters call Orange Peel) has hidden within it many additional patterns, which are achieved by deleting some lines.

Using simple tools like graph paper and a compass, you can design many sashiko patterns, but nothing beats a computer design program to make it faster and easier. I use Electric Quilt 5 to draw my patterns and have spent many an hour playing with the settings to come up with the perfect design for a project. There is the added advantage of being able to specify the exact-size block you want and having the computer print out a pattern for you.

To pursue the hidden designs in Seven Treasures of Buddha, I printed out a few sheets of the pattern and started doodling. By highlighting some of the lines in the pattern you can find many other patterns. Obviously, you will want to change the scale of your Seven Treasures of Buddha background design for some of the larger patterns.

Drawing Sashiko Patterns

In books you'll often find sashiko designs repeated as a continuous design, such as in the illustration below. To create a template, just isolate the individual element of the design and trace it onto template plastic.

But what if the design is not the size you want? And what if you don't have a computer? Let's walk through the steps necessary to choose a sashiko pattern, draft it the right size, and make a template without the aid of a computer. You will then use the template to draw the pattern onto paper or directly onto your fabric. This method works for all of the patterns that can be broken down into one design element, which can then be repeated across a grid.

1. As an example, let's say that you're choosing the Clamshell pattern. A single shell will be the individual element of your design.

2. Determine the size of your desired finished design. That is determined by where you will use the design: in a block, setting triangle, border, or other area of the quilt.

3. Decide on a grid size. This depends on how big your finished design will be and how simple or complex the design element is. For an 8" finished block, a 2" grid would be a good choice. It divides evenly into 8" and would give you 16 repeats of the Clamshell. We'll use that in our example.

4. Draw the 2" grid onto paper or fabric. If you draw directly onto fabric, you will have to remove these lines later, so don't make them too dark. Refer to "Marking" on page 11 for further details. You may choose to draw the pattern onto paper and use a light box to trace the final design onto your fabric.

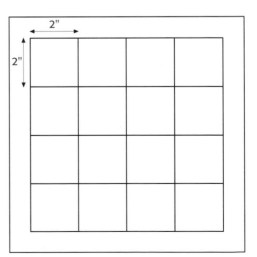

5. To make the template for tracing, draw a 2" square on a sheet of graph paper. For the clamshell, use a compass with the radius set at 1" to draw the motif within the 2" x 2" square. Note that compass points are marked with an X on the patterns.

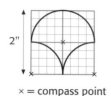

× = compass point

6. Trace the motif onto clear template plastic, including the 2" square around the motif (the placement line), and cut out both the square and the motif. If you can cut without damaging the template plastic, you will have two pattern pieces: the actual motif, which I call the positive template, and the square with the shape cut out. I call that a negative-space template. I usually use the negative image for tracing. If your pencil slips when marking with the positive image, then the mark you made is on the fabric and it must be removed. If you slip when using the negative image, the mark is on the plastic and doesn't cause a problem. The square is also helpful for lining up with grid lines drawn on the fabric or paper.

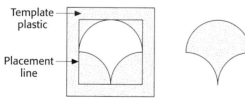

Template plastic

Placement line

Negative image Positive image

7. Line up the negative-space template with the grid lines and trace the pattern 16 times.

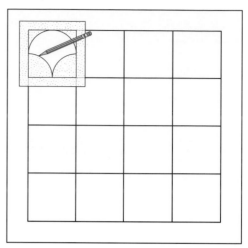

Line up placement lines on template
with grid lines on fabric.

Computer-Assisted Sashiko

If you don't have a quilt-design program, such as Electric Quilt, for your computer, make friends with someone who does. Bribe her with a batch of cookies (or chocolate or wine) and ask her to print out a few sashiko patterns for you to trace. Keep these in a file folder so that you can use them multiple times. My plan is to always work in an 8" block size because then I can print the patterns out on 8½" x 11" paper and never have to draw another pattern again.

Another advantage to working with Electric Quilt is that there are some great resource books that can be used with the program. Patti R. Anderson has written a book with a section specifically on drawing sashiko designs. Mary Ellen Kranz has a book with all the details of printing onto fabric. By combining these two things, you can draw a sashiko design on your computer and, with an ink-jet printer, print it directly onto fabric. This eliminates a lot of work and ensures an accurate design. See "Resources" on page 111 for further information.

Choosing a Marker

Marking pens and pencils take up a large section of my toolbox because there isn't any one marker that will work in every situation. Don't forget that not all of the lines you draw onto the fabric will be sewn over, so you must be able to remove the lines later. Always do a test on a piece of the same fabric you plan to use in your quilt to make sure you can remove the marks.

Colored pencils. I started out using *cheap* colored pencils. I emphasize the word cheap because an artist friend of mine told me that her colored pencils—the very expensive "official artist" ones—had oil in them and we certainly don't want that on our fabric. My grandchildren don't know that boxes of colored pencils come with light colors—I keep the white, yellow, and cream pencils and give them the rest. The downside is that it's hard to keep a sharp point on a pencil, and sometimes the lines they make arc too wide.

Soapstone markers. After colored pencils, I graduated to soapstone markers. They have a nice sharp point, but you need an electric pencil sharpener to sharpen them. (Whenever I sharpen them, the cat leaves the room—the sound must be pretty hard on her ears.) The downside is that the marks often rub off before you get them sewn.

Iron-off markers. My most recent find is the iron-off markers from Clover. They leave a nice sharp line that does not rub off while you are working, and the marks disappear with a little puff of steam from your iron. The downside is they don't work well on textured fabric, and you can't use them with fusible batting.

Mechanical pencils. Occasionally, I stitch the sashiko designs before layering the fabric with backing and batting. On those occasions I fuse a piece of muslin to the wrong side of my fabric, mark the design on the muslin, and sew with the decorative thread in my bobbin. This is handy when you want to work with a thread that is too delicate (or too thick) to sew through the needle. An ordinary graphite pencil works here. Avoid pencils with soft lead (HB), but mechanical pencils with harder lead (2H or 4H) work very well.

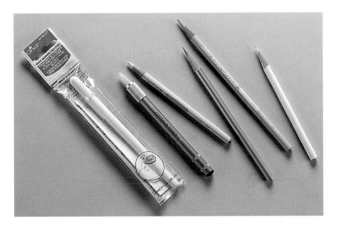

Marking pens and pencils from left to right: Clover iron-off markers, soapstone marker, and colored pencils

Marking

I have to admit that the least interesting part of doing sashiko is marking the patterns onto your fabric. The plus side of marking is you can develop a great fantasy life while doing it. Only a very small part of the brain will be engaged, so that leaves you the other 90% to pursue more interesting things: Brad . . . Keanu . . . Sean . . . (pick your age group).

Marking Directly on Fabric

Be sure to read "Drawing Sashiko Patterns" on page 9 for details on choosing a pattern, deciding on a grid size, and making a template.

1. Tape or secure your fabric in place on a smooth, hard surface.
2. Draw the grid onto the fabric using your chosen marker and a rotary-cutting ruler. I usually start by drawing what I call the gutter line. If I have cut a 9" block and I want the motif to be

sewn inside an 8" square, then I draw a line ½" from the left and bottom edges and draw the grid from those lines.

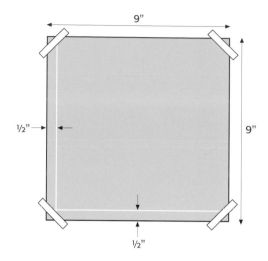

3. Line up the negative-space template you made with the grid lines. Hold it steady and trace the pattern within the grid square. Repeat to fill the grid.

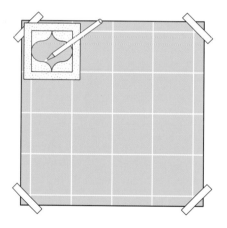

Marking on Fabric Using a Light Box

1. Trace your chosen sashiko pattern onto paper or template plastic. (Refer to "Drawing Sashiko Patterns" on page 9 for details on choosing a pattern, deciding on a grid, and drawing it onto paper or template plastic.) Be sure to make your lines very bold so that you will be able to see them through dark fabric.
2. Place the sashiko pattern on the light box and tape it to prevent movement. Place the fabric on top with the right side facing up; tape the fabric to the light box as well.

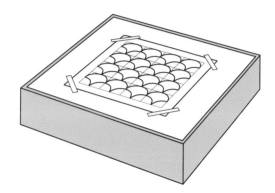

3. Trace the pattern using your chosen marker.

Thread

To achieve the look I wanted in a sashiko design, I knew I had to use a very heavyweight thread; since my first choice is usually 100% cotton, that's what I tried first. However, it turned out that some heavyweight cotton thread is quite stiff and inflexible. Many sashiko designs require 90° corners, and if the thread won't allow that, you will get very disappointing results. A good test of the flexibility of a thread is to fold it in half and see if it will give you a crisp fold. If it won't, chances are good that it will not perform well as a sashiko thread.

So, my search for the perfect sashiko thread began. As with most things, there is more than one solution, but the thread I turn to most often is YLI Jeans Stitch. This 100%-polyester, heavyweight thread gives very good results in both the needle and the bobbin, although not both at the same

Marking Time-Savers

One laborsaving device is to make a set of grid templates to use on a light box. I got some sheets of used x-ray film when I went for my mammogram (notice how I slipped in that reminder about mammograms) and drew my favorite grid sizes onto them. So instead of having to draw a grid onto my fabric every time I want to make a block, I just put my grid template on the light box, tape my fabric to it, and then trace the template that I want.

Another laborsaving device is to look for commercial stencils with sashiko designs on them. The best selection I found was from StenSource. See "Resources" on page 111 for their online catalog, or ask your local quilt shop to order them for you.

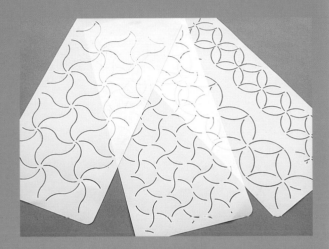

Stencils from StenSource. See "Resources" on page 111 for further information.

time. It comes in a wide variety of solid colors and some beautiful variegated ones.

Also from the YLI Corporation is their 100%-cotton thread called Colours. It is flexible enough to give you good corners, but strangely enough for a cotton enthusiast, I prefer the polyester Jeans Stitch for sashiko because it makes a stronger statement. From a distance, Jeans Stitch shows up better than Colours.

Another thread I have enjoyed using is heavyweight silk. It is a bit pricey (but hey, we're worth it), it has a beautiful sheen, and it sews like—well, like silk. I have trouble finding it, but when I do, I pick up a few spools.

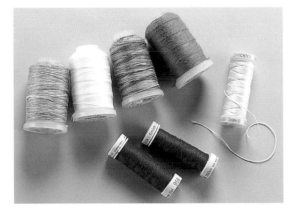

Four heavyweight threads (top), heavyweight silk thread (right), and two 50-weight threads to use together (bottom) for sashiko

Laura Wasilowski hand dyes heavyweight thread to match her beautiful hand-dyed fabrics. The thread is too heavy to sew using a needle but works beautifully in the bobbin. It comes in skeins so must first be wound by hand onto a bobbin. See "Resources" on page 111 to find out how to order some of this gorgeous stuff.

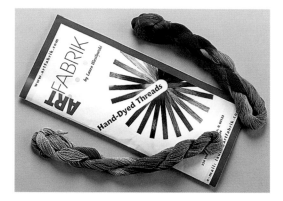

Hand-dyed thread by Laura Wasilowski

Essentially, I recommend trying any heavyweight thread you can get your hands on. Sew a sample and see how it works. I have found quite good thread in the most unexpected places. I once found a wonderful selection of thread intended for use in upholstery. The colors were good and the price was right so I bought one of each color (kind of like buying shoes).

But, what do you do when you just can't find the color you want in a heavyweight thread? I once went looking for a beautiful raspberry-colored thread and couldn't find one. What I did find, however, was the perfect shade of raspberry in a 50/3 weight. Hmmm . . . what would two strands of 50-weight thread look like sewn into my fabric? So, I bought two spools and went home to try them. With both strands of thread on the same side of the tension disc and threaded through the same needle, I did a test and it looked beautiful. The two strands of 50-weight thread together gave me the look I wanted, and the thread performed beautifully. I didn't have any skipped stitches or twisted thread and I couldn't have been happier with the results.

What this taught me, of course, is that I now have the same wide range of colors for sashiko as I have for normal sewing.

Needles

After you have found the perfect thread, you must find the appropriate needle. And, keeping in mind the relationship between the size of the needle and the size of the thread you use, my choice for most heavyweight thread is a size 100/16 topstitching needle. The topstitching needle has an enlarged eye, which makes threading it a snap, particularly when using two strands of thread at once. It also has a deeper groove to accommodate the heavier thread.

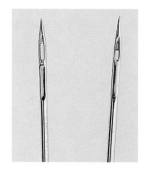

The topstitching needle is on the left.

Stopping and Starting

When choosing sashiko designs, look for ones that are continuous-line patterns. The patterns included in this book have minimal stops and starts—a big plus when machine stitching.

Not a continuous-line pattern A continuous-line pattern

Some hand-sashiko patterns can be turned into continuous-line designs by simply adding connecting lines.

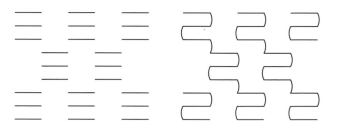

Because the heavyweight thread that we will be using is too bulky to backstitch with, you will have to tie a square knot and bury the thread end whenever you break your thread. Now, I don't know about you, but this is not something that I enjoy doing—it's hardly enough to keep the mind alive. My husband used to tease me when I spent an hour trying to draw a map through a design to avoid having to break my thread and deal with the knot issue. However, when I suggested that he learn to tie off the ends for me, he quickly agreed that it was worth my time to keep looking for the least number of stops and starts.

If the design runs into the seam allowance, I sew the thread ends into the seam allowance, but usually I try to keep the sashiko designs inside the seam allowances.

Another option for avoiding thread breaks is to sew over one part of the design twice. This is often the easiest way to avoid breaking your thread, and as long as you get the needle in exactly the same holes it is often hard to detect.

The bracketed area has been sewn over twice.

Machine Setup

I am often asked if I use a special stitch on my machine to do sashiko, and my answer is no. I use an ordinary, garden-variety straight stitch—the one that is usually the default stitch on your machine. I set the stitch length a little longer than normal—about 10 stitches per inch. Attach the walking foot or even-feed foot for your machine, or use the built-in walking foot if your machine has one.

For traditional sashiko, which is white thread on navy blue fabric, thread your bobbin with a navy blue 50/3-weight cotton thread, and thread the needle with one of the heavyweight white threads discussed above.

Our goal is to make the stitching look as much like hand sashiko as possible. To do this, increase the upper tension on your machine (if necessary) so that the bobbin thread is pulled up to the top surface when you are stitching. You want to see a bit of the navy blue bobbin thread showing on the top so that instead of a continuous white line, you will see stitch definition. Often it isn't necessary to increase the top tension since the heavyweight thread automatically pulls the lighter-weight bobbin thread to the top. Always test your stitch length and tension on scraps of the same fabric you plan to use in your project. Make all necessary adjustments before you start working on the real thing.

Adjusting Stitch Length

One of the "rules" when doing sashiko by hand is to have the same number of stitches in each repeat of a segment in the design. For instance, if you were stitching the pattern Pine Bark and you had three stitches in the short section and eight stitches in the long section of the design, then you should have the same number of stitches in every repeat. Fortunately, our machines will look after the stitch length for us, but you first have to set the machine to the appropriate setting. Follow the procedure below to set stitch length for any given pattern.

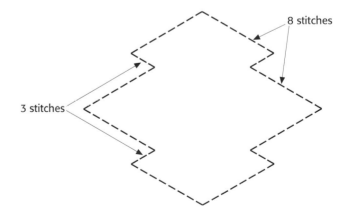

1. Draw one Pine Bark pattern onto your fabric and layer with backing and batting, referring to "Marking" on page 11 if needed.

2. Thread your machine with your chosen thread and set your machine to a long stitch—about 10 stitches per inch.

3. Put the needle in the fabric at the top of the pattern and stitch until you reach the first pivot point. Your goal is to have the needle go into the fabric exactly at the pivot point. Count the number of stitches—with my chosen stitch length on a 2½" motif, the number of stitches is eight.

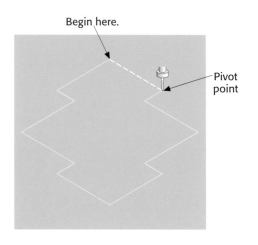

Begin here.

Pivot point

4. Stitch the next section of the pattern and count the number of stitches. For the Pine Bark pattern, I typically get three stitches on my machine. Again you want the needle to go into the fabric right at the pivot point. If you fall short, then you must lengthen your stitch a bit.

Conversely, if you go beyond the pivot point, then you must shorten your stitch. When you have the machine set so that the needle goes into the fabric exactly at each pivot point, make a note of the stitch length you used and mark it on your template.

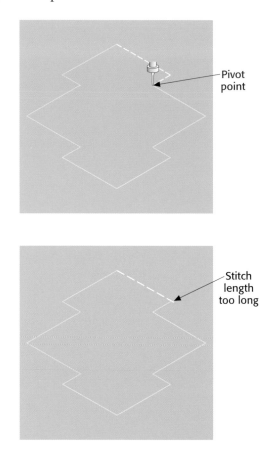

Pivot point

Stitch length too long

Sewing-Machine Blues

I have taught sashiko by machine many times, to many students, and the most frustrating thing is that some machines simply will not accept the two different weights of thread. No amount of adjusting the tension (both needle and bobbin) will produce a good stitch on these machines. I have never been able to get a reasonable explanation from a salesperson as to why this is the case, but I know that when a student has such a machine, she is not a happy camper. My hope is that yours is not one of those machines.

If you do have difficulty achieving good stitch quality, take your machine to be serviced and ask how to adjust the tension so it will accept the two different weights of thread. If this can't be accomplished, I'd write a letter to Santa Claus asking for a machine that will do what you want it to. Think like a man—if you have a machine that doesn't do the job, get another one that does!

Don't worry if your stitching is not completely consistent. Just be sure that the needle enters the fabric at the pivot point. Any small inconsistencies will probably not be noticeable and will give your piece more of a hand-stitched look. If you like the look, that is what really matters.

The Ins and Outs of Stitching

You've marked your fabric and layered it with batting and backing. Once you've chosen your thread and needle and made adjustments to tension and stitch length on a practice piece, you're good to go.

1. Leave a thread tail about 4" long. Hold onto the thread ends, if necessary, and begin stitching at an appropriate starting point or where indicated on a pattern.

2. Follow your marked line, stopping and pivoting whenever necessary to stay on the lines. This can be quite often for tight curves. Be sure to stop with the needle down in the fabric when pivoting. Use that feature on your machine if it has one. Sew slowly, and pivot whenever you see the fabric start to bunch.

Lighten Up
I find that if the pressure on the presser foot is too great, then more pivoting is necessary. On my machine I can reduce the pressure when sewing on a quilt sandwich and that helps with sewing curves.

3. Sew and pivot along the marked design lines as long as you can before stopping. To stop, simply lift your presser foot and cut the threads, leaving a tail approximately 4" long.

Stitching Advice
I try to keep the fabric as flat as possible at all times. Pushing and shoving doesn't help. Let the feed dogs do their job; your job is to steer, and if that means you have to stop occasionally and pivot, then that's what you do. I don't think it's possible to pivot too much.

4. To tie off the thread, thread the top tail into a needle with a large eye and a sharp point. Insert the needle through the layers and pull the thread to the back. Tie the two tails into a square knot (right over left, left over right). Put both thread ends through the eye of the needle and insert the point into the closest machine-needle hole. Bring the point up through another hole (still on the back side of the quilt) made by the machine an inch or so away from the knot. Pull the needle through and gently ease the knot into the batting layer. Trim the thread ends even with the surface of the quilt. Wiggle the fabric around a bit so that the thread ends disappear into the hole.

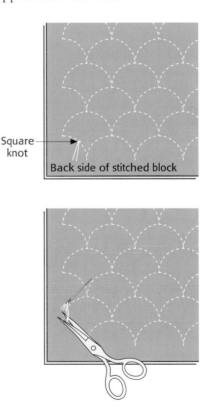

Square knot

Back side of stitched block

Sashiko on a Single Thickness

The first piece of sashiko I saw was a tablecloth, done by hand, on a single thickness of indigo fabric. It was purchased in Japan and was loaned to me by a friend who took my car as security until I gave it back to her. Well, not quite, but it was a treasure, and when I went looking for one in Japan, I realized why she was so protective of it.

As you probably know, it is not possible to sew on a single thickness of fabric with your sewing machine unless you use a hoop; the fabric will pucker and your stitching will be uneven. When I want to achieve the look of a single thickness, I adhere a piece of muslin to the wrong side of my navy blue fabric (or other chosen fabric) with basting spray, and sew "upside down."

1. Use a basting spray (such as 505 Basting Spray). Follow the manufacturer's instructions to spray and adhere a piece of muslin to the wrong side of the navy blue fabric. Make a small second piece using the same fabrics to test your stitch length and tension.
2. Mark your sashiko design on the muslin.
3. Thread your machine with heavyweight white thread in your bobbin and 50/3 navy blue thread on top. Use a size 80/12 universal needle.
4. Do a dry run on the practice sample to set the tension and stitch length. It may be necessary to loosen the upper tension to make sure you can see some of the navy blue thread on the bobbin side.
5. Leaving long tails at the beginning and end of your design, stitch your pattern.
6. Thread the top tail into a needle and take it to the wrong side of your work. Tie a square knot with the bobbin tail and clip the ends, leaving an inch of tail beyond the knot. Do this at the beginning and end of your stitching.

Muslin Alternative
Another option for stitching on a single thickness of fabric is to use a water-soluble sheet of stabilizer, such as Solvy. When the stitching is done, simply rinse the stabilizer away and you'll have a single layer of fabric. This is especially nice for appliqué, to eliminate the layer of muslin.

My Favorite Battings

I prefer the look of sashiko done on a quilt sandwich, which is the traditional three layers of a quilt. The hills and valleys created by stitching through batting make it much more interesting. Consequently, you'll see that most of my sashiko is done with batting.

My favorite batting is one that has some polyester in it, for strength, and also a large percentage of cotton. The one that I am most fond of is Hobbs Heirloom Cotton Batting, which is 80% cotton and 20% polyester. It requires that you quilt every 4½", which is usually not a problem, but if I do want to make something with less quilting, then I switch to Hobbs Organic Cotton Batting with Scrim, which allows you to leave up to 8" unquilted.

I have fallen in love with the Hobbs Heirloom Fusible Cotton Batting, which is cotton batting with a thin layer of heat-activated "glue" on both sides. The fusing is not permanent, so if you change your mind and want to reposition something after you have fused it, you can just peel it back. The glue washes out with the first washing of your quilt, and I love not having to pin my blocks and then stop and remove the pins while quilting.

Note: If you are planning to use the fusible batting, do not mark your sashiko designs with the Clover iron-off marking pen. When you use your iron to fuse the batting in place after carefully marking your design, all of your marks will disappear. Oops!

Other Fun Sashiko Options

Digitized Designs

If you have an embroidery machine, check out the Web site of Kaz McAuliffe. She has digitized many sashiko designs, including ones that are not continuous-line designs. Stopping and starting are not issues on embroidery machines so it isn't necessary to avoid these patterns. At right are 10 wonderful examples of sashiko designs digitized and stitched by Kaz.

Painted Designs

Another creative alternative to achieve the look of sashiko patterns is to paint them onto your fabric. The delightful sample shown below was made with Lynell Harlow's stencils and oil-paint sticks.

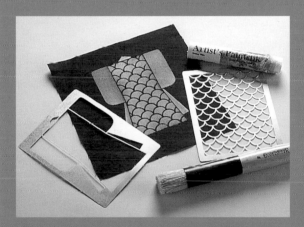

Paint beautiful sashiko patterns onto fabric with stencils and oil-paint sticks.

See "Resources" on page 111 for more information on both of these options.

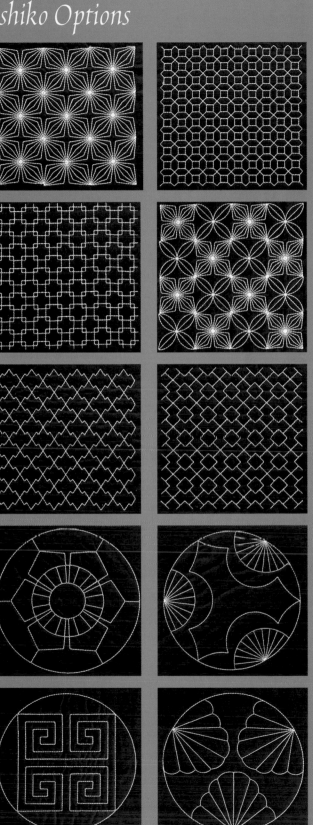

Since I learned how to join quilted blocks together, I have made only one quilt the conventional way and I didn't enjoy the experience. It was difficult to struggle with a large quilt when machine quilting. And the most difficult part of all was cleaning off my worktable so I had room to baste it!

I think you'll agree that it is much easier to machine quilt a small block, then join it to its neighbors using sashing. The following instructions will explain my reversible technique.

Basic Sashing

Basic sashing is used to join the reversible blocks. The sashing finishes at ⅝" wide on both sides of the quilt. You will cut strips of different widths, however, for the two different sides—1⅛" wide for one side and 1¾" wide for the other. It doesn't matter on which side you use the two widths.

1. Cut 1⅛"-wide strips from one sashing fabric, and then cut 1¾"-wide strips from the other sashing fabric. Cut across the full width of your fabric.
2. Fold the 1¾" strips in half lengthwise, wrong sides together, and press.
3. Use the full length of the strips. On side A, align the raw edges of the folded strip with the raw edges of the first block to be joined. On side B, align the raw edge of the 1⅛"-wide strip with the raw edges of the same block, right sides together. Sew both sashing strips to the first block with a ¼" seam. You are sewing both sashing strips to the same block at the same time.

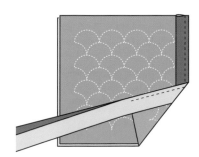

4. Trim the ends of the strips even with the top and bottom of the block.

5. Sew the second block to the raw edge of the 1⅛"-wide strip, right sides together. The edges of the two seam allowances should meet in the middle of the sashing strip and fill the space between the two blocks. If there is a gap between the two edges, increase your seam allowance; if the two edges overlap, decrease your seam allowance.

Raw edges should meet.

6. Continue sewing sashing strips between the blocks until you finish the row. You now have three of the four edges of the sashing strips sewn by machine. Pin the folded strip in place, covering the machine stitching. Sew the remaining folded edge by hand or machine (see "Finishing the Sashing by Machine" below right).

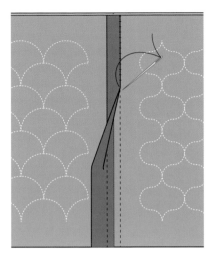

7. To join the rows or to add a border, follow the same directions as for joining block to block but use longer sashing strips. If you need to piece sashing strips, sew the ends together with a diagonal seam. Trim the excess fabric and press the seam open.

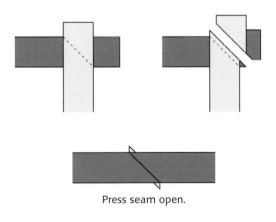

Press seam open.

8. When joining horizontal rows of blocks, be sure to line up the vertical strips between the blocks from one row to the next.

9. To add borders to a reversible quilt, refer to "Reversible-Quilt Borders" on page 28.

Finishing the Sashing by Machine

If you choose to sew the remaining side of the sashing by machine, here is my favorite way to do that. Set the machine to a very narrow zigzag stitch. Thread the machine with 60/2 cotton thread that matches the sashing fabric and use a 60/8 needle and invisible nylon thread in the bobbin. Pin the folded strip in place and sew along the folded edge.

Another option is to set the machine to do a decorative stitch and use a decorative thread in both top and bottom. This is particularly nice on a binding.

Machine Appliqué— My Version

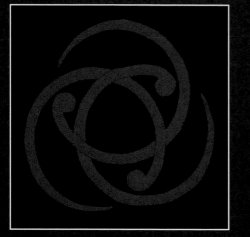

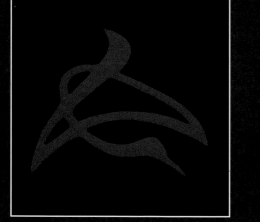

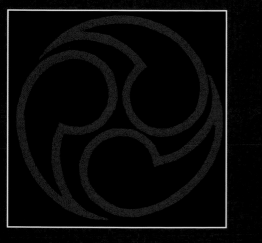

There are as many ways to appliqué as there are quilters, and if your system works for you, please feel free to ignore this section completely. My hand appliqué was so poor I had to learn how to do it by machine or give up appliqué altogether. Some of my friends remember a time when I referred to appliqué as "the A word," and they take great delight in reminding me that I swore I'd never do it. The day I realized it could be done by machine was the day I decided to give appliqué a chance.

My method uses freezer paper and rubber cement, available at stationery and hardware stores. I prefer rubber cement to the other glues that are available because it only sticks to itself. If you get some on your fingers you can still manipulate the fabric you are working with. My track record with glue sticks is not good; invariably I get some on my fingers and then when I try to place a small appliqué piece onto my block it just sticks to my finger.

To prepare the pieces for appliqué:

1. Using a pencil—not a pen—trace your design onto the uncoated side of freezer paper. Your appliqué will be the mirror image of what you draw. Therefore, if the pattern is directional and you want the appliqué to face the same direction as the pattern, you will need to reverse the pattern first.

Uncoated side of freezer paper

2. Cut on the drawn lines; do not add any seam allowance. In some cases, the negative image is the part of the pattern that you will use; do not discard either piece of the design.

22

3. Iron the freezer-paper template to the wrong side of your fabric and cut the excess fabric away, leaving between ⅛" and ¼" seam allowance. Clip curves if necessary.

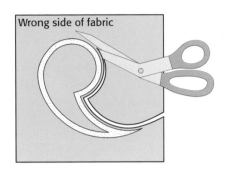

Wrong side of fabric

4. Using a small disposable bristle brush (no more than ⅛" wide), put a small amount of rubber cement on the edges of both the fabric seam allowance and the freezer paper. Rubber cement sticks only to itself so you must put some on both pieces. I place the brush so that half of it is on the fabric and half is on the paper; you don't want to glue the whole seam allowance down so make sure you don't stray too far from the edge of the paper. That will make the freezer paper easy to remove later. Allow the glue to dry; this takes only a minute. If it's shiny, it hasn't dried yet.

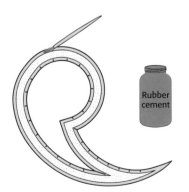

Rubber cement

5. With a round toothpick, or any other tool you find useful, turn the seam allowance over onto the freezer paper. When you come to a corner, put another dab of glue onto the fabric after you have turned it over so that when you turn the next edge it will stick.

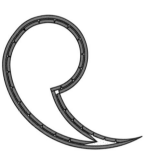

Turn seam allowances over onto freezer paper.

6. Using your pattern-placement guide, position the appliqué pieces onto the background fabric. Tape them in place with regular tape, such as Scotch Magic tape (it can be difficult to pin through freezer paper).

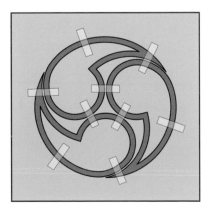

7. Appliqué in any way you choose, by hand or using your favorite machine stitch. I stitch by machine. Please read on for further details.

Invisible Machine Appliqué

To achieve nearly invisible stitches by machine, it is necessary to use a very fine thread and an equally fine needle. My first choice is always cotton thread and if my appliqué is a solid color, I choose a thread to match. However, that is often not possible, either because I am using a print or because I can't find the right-colored thread. In that case I use invisible thread. Either way, I use the smallest needle possible because often what you see on a machine-appliquéd piece isn't the thread, but the hole that was made by the needle.

With the exception of the universal needle, all of the others (quilting, embroidery, Metallica, denim, and Microtex) leave a permanent hole in the fabric. The universal needle was designed to work well on both knits and woven fabrics so it doesn't make permanent holes (which would cause runs in knit fabrics); it will help make your machine appliqué invisible. The reason the universal needle doesn't make a permanent hole is because it is not as sharp as the other needles. It is halfway between a sharp point and the very round point of stretch needles. When it hits a fiber, it is diverted to one side or the other and doesn't leave a permanent trail of holes.

1. Thread your machine with either 60/2 cotton thread in an appropriate color, invisible nylon thread, or invisible polyester thread. Your bobbin thread should be 50/3 cotton thread in a color to match your appliqué. Use a 60/8 universal needle.

2. Set your machine to do a very narrow zigzag. On my machine (Bernina 170) the width is .5 and the length is 2.5. You want to achieve the narrowest zigzag possible yet still see the needle moving from left to right. If you can't see the needle moving from side to side, you won't be able to guide it. Do a test to see how narrow you can set your machine and still manage to guide the stitching.

Use a very narrow zigzag stitch for invisible machine appliqué.

3. Anchor your stitching in the background fabric by setting your machine to do a very small straight stitch, then switch to the zigzag stitch and, with the needle going to the left, just catch the edge of your appliqué piece. When the needle goes to the right, you should be in the background fabric only, and so close to the appliqué piece that your needle brushes against it. The goal is to have the absolute smallest amount of appliqué fabric caught by the needle. Continue around the appliqué piece and anchor your stitches at the end.

4. From the wrong side, trim the excess fabric away, leaving a ¼" seam allowance, and remove the freezer paper. Use tweezers if you find them helpful.

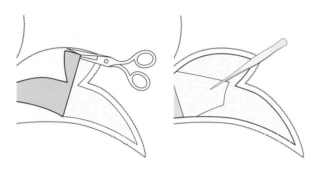

Trim background. Remove freezer paper.

5. It might be necessary to touch up your piece with an iron after removing the freezer paper. Don't worry about melting the invisible thread; you would scorch your fabric before it would melt.

Circular Framing

In many of my quilts I have used an appliquéd circular frame or border around an appliqué design. I like the way the appliqués look within a circle, and it mimics the Japanese family crests, which often appear within circles. With the use of freezer paper, it is easy to get a perfect circle template.

1. Draw a circle onto the uncoated side of a square of freezer paper. The instructions for each project tell you what radius the circle should be.

The freezer-paper square should be the same size as the fabric you are using as the frame.

Uncoated side of freezer paper

Radius

2. Cut out the circle and save it for another project; you will use the negative image for framing. Iron the freezer paper onto the wrong side of your framing fabric.

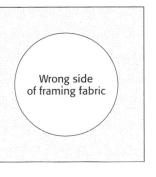

Wrong side of framing fabric

3. Cut the excess fabric inside the circle away, leaving between ⅛" and ¼" seam allowance. Clip halfway into the seam allowance every inch or so.

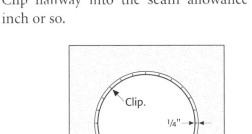

Clip.

¼"

4. Apply rubber cement to both the edge of the freezer paper and the seam allowance of the

fabric. When dry, turn the seam allowance over onto the freezer paper.

5. On the wrong side of the circular frame, center the background fabric over the opening and tape in place. Check from the right side to make sure the design is centered (if the appliqué has already been completed). You can do the appliqué in the center before or after the circular frame is appliquéd.

Wrong side of background fabric

6. Appliqué the frame to the background by hand or machine.
7. Trim the excess background fabric from the wrong side, leaving a ¼" seam allowance. Remove the freezer paper.

Wrong side Right side

Drawing Large Circles

As you go through this book, you will see many circles used—Japanese family crests are always enclosed in a circle. Some of my circles are quite large, beyond the scope of a compass to draw. To manage the larger circles, I use a ruler designed by Nancy Crow called the Quickline II (see "Resources" on page 111). With holes running down the middle that are big enough to get a pencil through and another hole on the end large enough to put a pin through, you can draw a circle with a radius up to 24". I tape the fabric to my work surface and usually invite a friend (or a retired husband) in to help. The hardest part of the whole operation is making sure your worktable is cleared off.

If you don't have one of these wonderful rulers, the old pencil-and-string method works too. Tie the string around the pencil as close to the pointed end as possible; the string needs to be a few inches longer than the radius of the circle you are drawing. Measure the radius along the string and tie a knot in it at the appropriate spot. Put a pin through the knot. Put the pin in the center of your fabric and, holding the pencil perfectly perpendicular to the string, draw your circle. Again, it helps if you have a friend hold either the pin or the pencil.

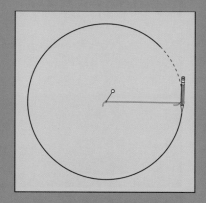

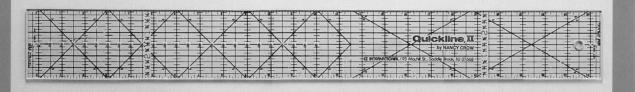

*The Quickline II ruler is very handy
for drawing large circles.*

Mitered Borders

A few of the quilts that are not made with the reversible method include mitered borders. They add a nice touch to your quilts and they're not hard to do.

1. Measure the dimensions of your quilt through the middle.

2. Add twice the width of the borders plus 2" on each end (4" total), to be on the safe side, to the quilt dimensions from step 1. Cut the two side border strips and the two top and bottom border strips to those lengths.

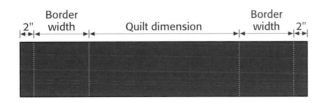

3. Find the center of one side border strip and pin it to the center of the side of the quilt.

4. Starting ¼" from the end, stitch to within ¼" of the other end. Backstitch at each end to secure the seam. Repeat for all four sides. Press the seams toward the border.

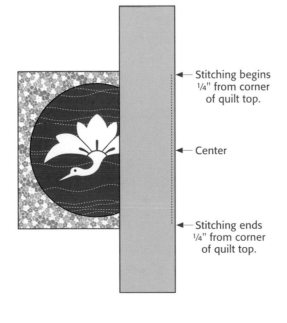

5. On your ironing board, fold the top border piece at a 45° angle to the bottom piece and press.

6. Fold the two border pieces right sides together, and, if necessary, draw a pencil line on the crease so you can see where to sew.

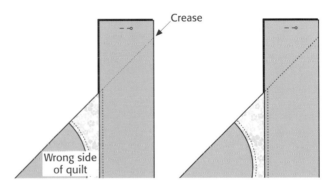

7. Stitch on the crease from the end of the previous stitching line to the outside edge. Repeat for all four corners.

8. Check on the right side to see that the miters are sewn correctly. Then trim the excess fabric, leaving ¼" seam allowance. Press the seams open.

Borders on reversible quilts are joined to the quilt with sashing strips, just as rows of blocks are joined together. The sashing fabric used to join a border to a quilt can be the same as the border fabric or a contrasting fabric. If you use a contrasting fabric, the sashing will look like an inner border. If you use the same fabric, it just disappears. It all depends on the look you want.

Basic Borders

I cut borders 1" wider and longer than the desired finished size—½" for seam allowances and ½" to allow for any slippage when quilting.

1. Measure the length of your quilt through the center. Add an extra 1" in both directions.

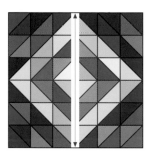

2. Cut border strips for each side of the quilt according to your measurements, piecing them if necessary. Cut strips of batting the same size.
3. If you are using fusible batting, fuse the three layers together. If you are using regular batting, pin or spray baste the three layers together with the batting in the middle.
4. Quilt as desired.
5. Trim to the desired length and width, leaving ½" for seam allowances.
6. Join the border strips to the sides of the quilt with sashing strips, as you do for blocks and rows (see "Basic Sashing" on page 20 if needed).

7. Measure the width through the center, add an extra 1" in both directions, and repeat steps 2–6 to add the top and bottom borders.

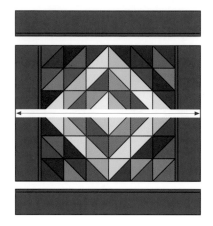

Borders with a Contrasting Inner Border

In "Praise to Pippen" on page 99, you'll see that the sashing that joins the border to the quilt looks like an inner border. To achieve this look, join the top and bottom border strips to the quilt using a contrasting fabric for the sashing. For the sides, sew a short strip of border fabric to each end of a side sashing strip. Sew the side border strips to the quilt with the pieced sashing strips.

Finishing

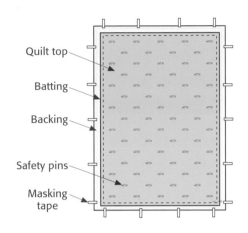

If you've chosen the reversible-quilt construction method, the only finishing you need to do is the binding. If you have just completed your quilt top, now is the time to prepare it for quilting. Mark any quilting designs on the top before layering and basting. Refer to "Marking" on page 11 as needed.

Traditional Layering, Basting, and Machine Quilting

When the quilt top is complete and marked as desired, you will assemble the quilt sandwich—the backing, batting, and quilt top. The backing and batting should be at least 4" larger than the quilt top. If your quilt is wider than your fabric width, you will need to piece the backing. Piece it either horizontally or vertically to make the most efficient use of your fabric.

Refer to "My Favorite Battings" on page 18 for helpful information on choosing a batting. Batting comes packaged in standard bed sizes or it can be purchased by the yard.

1. Spread the backing, wrong side up, on a flat, clean surface. Anchor it with masking tape or clips. Be careful not to stretch it too tight or stretch it out of shape.

2. Spread the batting over the backing, smoothing out any wrinkles.

3. Center the pressed quilt top, right side up, on top of the batting. Smooth out any wrinkles and make sure the edges of the quilt top are parallel to the edges of the backing.

4. To baste the layers together, use No. 2 rust-proof safety pins for machine quilting or fuse the layers together if you have chosen a fusible batting. Begin in the center and place pins in a grid about 6" to 8" apart. You can also use a basting spray to adhere the layers together.

5. For machine-guided quilting, use your walking foot. For free-motion quilting, drop the feed dogs and attach a darning foot to stitch the designs.

Maurine Noble's *Machine Quilting Made Easy* (Martingale & Company, 1994) is a great resource if you'd like more information about machine quilting.

Binding

Binding need not be just the "tidying up" bit at the end of making a quilt. Like sashing, it can play a decorative as well as a functional role. In some quilts, you may want the binding to just disappear, while in others you may want it to make a bold statement. The basic binding instructions that follow are those that I use for any quilt. Follow these instructions for quilts when the binding will be the same fabric on both sides. If you want the binding different on the two sides, see "Reversible Binding" on page 31. Yardage requirements for both basic binding and reversible binding are provided with each reversible project.

Basic Binding

I was taught this method of binding shortly after I learned to quilt and have always loved it. It makes a beautiful finished corner on both sides of the quilt; each side will have perfect, machine-sewn miters.

If you haven't done binding this way, give it a try. I like it because the two ends of the binding are enclosed in a corner so there is no need to do that horrible thing with joining the ends, which always looks messy when I try it.

From the width of the fabric, cut enough 2½"-wide strips to go around all sides of the quilt plus 8" extra for joining strips and turning corners. Join the strips end to end to make a long continuous strip. Join them with a diagonal seam as you did for long sashing strips (see page 21 for details if needed).

1. Fold the strip in half lengthwise, wrong sides together, and press.
2. Put the walking foot on your sewing machine.
3. Starting at a corner and leaving a 2" tail, match the raw edges of the binding with the raw edges of the quilt. Beginning ¼" from the corner, anchor your stitches and sew the binding to the first side of the quilt with a ¼" seam allowance. Stop ¼" from the next corner and again anchor your stitches.

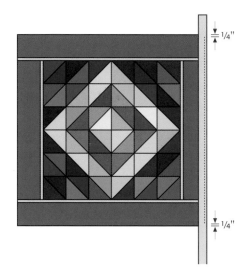

4. Remove the quilt from the machine. Draw a perpendicular line from the stitching line (A) to the fold (C). I call this the baseline.

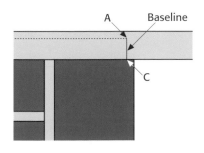

5. Measure the distance from the stitching line to the folded edge of your binding strip. It should be 1". Find the center of the baseline (it should be ½" from the folded edge and ½" from the stitching line) and make a mark. From that mark, measure ½" to the right of the baseline, and make another mark (B). Draw a line from points A and C to point B to form a triangle.

6. Fold the binding under at point B as shown. Pin in place. If you can't see the triangle you've just drawn and the folded edges are not aligned, it's folded the wrong way. Fold the quilt back out of the way and starting with the needle at point A, anchor your stitches. Then sew to point B, pivot, and sew to point C; anchor your stitches. Do not sew across the baseline.

7. Remove the quilt from the machine and align the binding with the edge of the next side of the quilt. Mark the point at which you start stitching point D; this is under point A (and also ¼" from the edge). With the needle at point D, anchor your stitches and then sew to ¼" from the next corner; anchor your stitches again.

8. Repeat steps 4–7 for the second and third corners. On the fourth side, sew to where you started (¼" from the end of side 4); anchor your stitches. Draw the ABC triangle as you did for the previous three corners, but instead of folding the binding under, pin it to the tail you left at the beginning, aligning the folded edges.

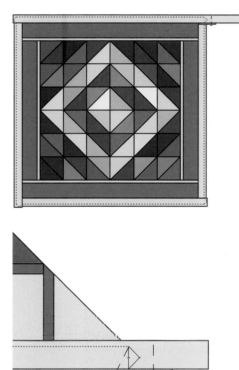

9. Sew the triangle through both pieces of binding, thereby enclosing the ends into the corner seam.

10. Trim the corners from each triangle and turn right side out. This will give you a mitered corner on both sides of your quilt.

11. Turn the binding to the reverse side and hand or machine sew the folded edge to the quilt.

Back side

Note: If you want to use strips wider than 2½" for your binding, the technique will still work. After folding and sewing the binding to the quilts, measure the distance between the stitching line and the folded edge (step 5) and divide the measurement in half. Use this measurement to mark the point of the triangle (B).

Reversible Binding

But what if the same binding fabric just won't do for both sides of the quilt? Reversible binding is easy to do, but you cannot do a mitered corner as you did for the basic binding. Instead, you will sew the binding to the sides first and then to the top and bottom edges.

1. From the width of the fabric, cut enough 1⅛"-wide strips to go around the quilt plus a few inches for the corners. Cut strips for the other side 1¾" wide. It does not matter on which side you use the two widths; as an example, in these instructions, the narrower strip will go on the front of the quilt. If the sides of the quilt are longer than 40", join the strips end to end with a diagonal seam as you do when piecing sashing (see step 7 on page 21).

2. Fold the 1¾"-wide strip in half lengthwise, wrong sides together, and press.

3. With right sides together and matching raw edges, sew the single layer of binding and the folded layer of binding together with a ¼"-wide seam allowance.

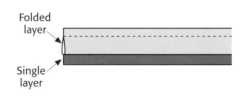

Folded layer

Single layer

4. Press the seam open. This helps the binding fold at the midpoint when you attach the binding to the quilt.

5. Sew the binding to opposite sides of the quilt first. With right sides together and raw edges matching, sew the single layer of binding to one side of the quilt. Trim the ends even with the quilt. Fold the binding at the seam line and hand or machine sew the folded edge to the reverse side of the quilt.

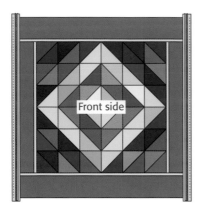

Front side

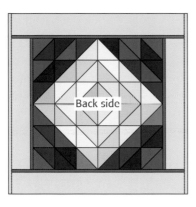

Back side

6. Leaving a ½" tail at the beginning and end, sew the single layer of binding to the top and bottom edges of the quilt.

7. With right sides together, sew the ends of the binding flush with the ends of the quilt. Make sure you keep the folded edge lined up with the folded edge of the seam allowance you have just sewn. Trim the seam allowance and turn right sides out.

8. Hand or machine sew the folded edge to the reverse side of the quilt as you did with the first two sides.

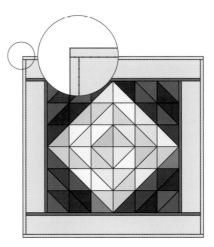

Crane: Two Variations

Let's start out with a small wall hanging. This pattern is the one I give to students who take my family-crests class. Most students manage to get the crane appliquéd in the six-hour class—some even get the borders on and some quilting done. It is one of the most beautiful of the crests and I think it has a wonderfully contemporary look to it while at the same time an ageless beauty. The simplicity is very pleasing and it is a restful piece to hang in a room.

On both of these variations I did some stitching on the navy blue background fabric with a decorative thread before doing the appliqué. It's much easier to do the stitching without having to stop and start whenever you bump into the appliqué pieces. Also, because the thread I used is very fragile and therefore impossible to sew through the needle, I put it in the bobbin and was able to sew from the wrong side.

You'll notice when you look at the appliqué pattern for the crane that there are details at the base of the wings that can be done in two ways. If you like appliquéing little intricate pieces, you can trace your templates on the dotted lines and appliqué them. However, if you would rather not have to fuss with those tricky little bits, you can trace just the outline of the wing and leave the detail to do later with a zig-zag stitch on your sewing machine. From a short distance, you can't tell which one has been appliquéd and which one has been stitched.

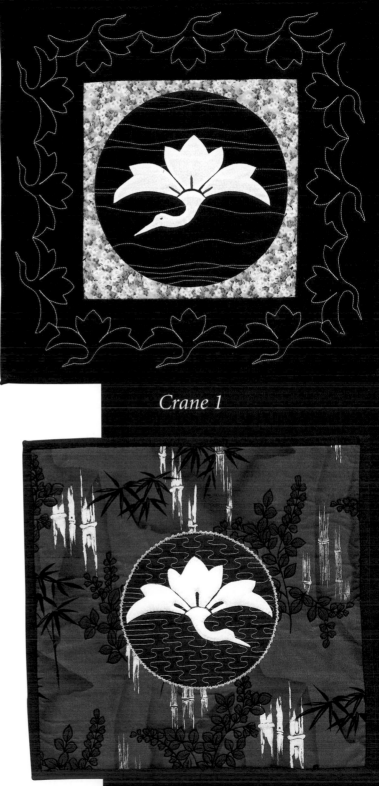

Crane 1

Crane 2

Crane 1

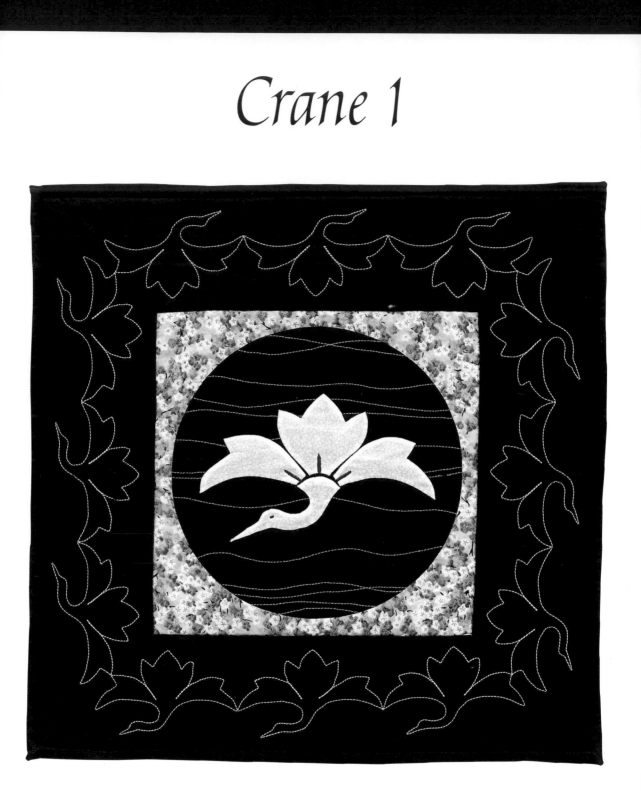

Quilt size: 19" x 19"

Materials

Yardage is based on 42"-wide fabric.

⅞ yard of navy blue fabric for background, borders, and binding

12" x 12" piece of blue-and-white print for circular framing border

11" x 11" piece of muslin for layering with the background

8" x 10" piece of white fabric for the crane

⅝ yard of fabric for backing

21" x 21" piece of batting

Compass for drawing a circle with a 4⅞" radius

Freezer paper

Cutting

From the navy blue fabric, cut:
1 square, 11" x 11"
4 pieces, 4½" x 22"
2 strips, 2½" x 42"

From the backing fabric, cut:
1 piece, 21" x 21"

Assembly

1. Referring to "Sashiko on a Single Thickness" on page 17, baste or spray baste the 11" navy blue square to the 11" muslin square.
2. Stitch random wavy lines on the navy blue square.
3. Referring to "Machine Appliqué" on page 22, or using your favorite method, prepare and appliqué the white crane pieces to the right side of the stitched navy blue background square. Use appliqué patterns on page 39.

About-Face

Using the freezer-paper appliqué method described on page 22, your crane will be facing left when you do the appliqué even though the pattern is facing right. If you prefer to have it facing right, just reverse the pattern to get the mirror image. To do that I use tracing paper and a dark marking pencil. I trace the pattern as it appears, then turn the paper over and use the reversed image on the other side. If necessary, trace over the lines on the reverse side to make them dark enough to see when you trace them onto your freezer paper.

4. Referring to "Circular Framing" on page 24, draw a circle with a radius of 4⅞" onto the uncoated side of a 12" square of freezer paper (this will give you a circle with a finished diameter of 9¾"). Use this circle to prepare and appliqué the blue-and-white print circular frame to the appliquéd background square. Trim the square to 11½" x 11½".

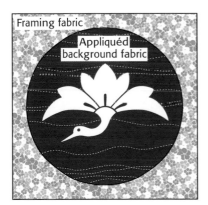

Framing fabric

Appliquéd background fabric

5. Referring to "Mitered Borders" on page 27, sew borders onto your quilt using the 4½" x 22" pieces of navy blue fabric.

6. Make a template using the sashiko pattern on page 39. Draw the crane motif onto the four borders, making sure that the lower wing tips touch along the sides. At the four corners, the upper wing tips should touch.

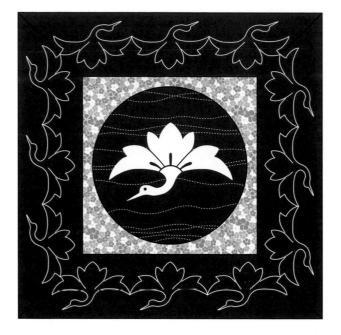

7. Layer the 21" x 21" square of batting, the backing, and the quilt top together and baste with pins or fuse if you're using fusible batting.

8. Quilt in the ditch around the crane appliqué pieces, the circular frame, and the square borders.

9. To quilt the sashiko crane motifs on the outer border, refer to "The Ins and Outs of Stitching" on page 17. Start at a wing tip on one corner and go all around the border in a continuous line, following the bottom half of the motif. When you reach the point where you started, do not break your thread; go around again following the top half of the motif, which will eventually bring you back to where you started. This enables you to do the whole border without having to break your thread.

10. Referring to "Basic Binding" on page 29, use the 2½" navy blue strips and bind the edges of the quilt.

Paper Perfect
To make sure border designs will flow and fit around a quilt, I often draw a full-sized pattern of the borders of the quilt on paper first. The stitching lines should be clearly marked, particularly the diagonal mitered seam at the corners. I use rolls of paper I buy at my doctor's office; it's the stuff they use to cover the examining-room table and it is perfect for drawing full-sized patterns. I use this paper for many purposes and I can make sure I have a template the exact size I need when I'm designing.

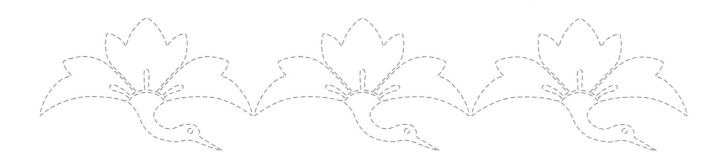

Crane 2

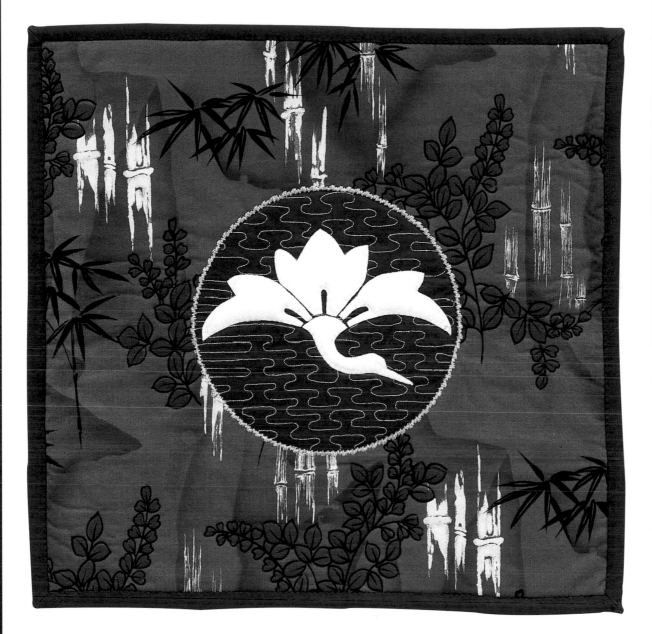

Quilt size: 18" x 18"

I wanted to feature a beautiful print in this wall hanging. Rather than cut the fabric into strips for a conventional border, I chose to appliqué the circle onto a square of the fabulous Japanese-style fabric.

Materials

Yardage is based on 42"-wide fabric.

1 fat quarter of focal fabric

10" x 10" piece of navy blue fabric for appliqué background

10" x 10" piece of muslin (if you plan to do stitching on your background fabric)

8" x 10" piece of white fabric for crane

⅝ yard of fabric for backing

¼ yard of navy blue fabric for binding

20" x 20" piece of batting

Freezer paper

Compass for drawing a circle with a 4¼" radius

Cutting

From the focal fabric, cut:
1 square*, 18" x 18"

From the backing fabric, cut:
1 square, 20" x 20"

From the navy blue fabric, cut:
2 strips, 2½" x 42"

If your fat quarter isn't quite big enough to cut it 18" x 18", cut it as large as you can.

Assembly

1. Do the decorative stitching on the appliqué background first, referring to "Sashiko on a Single Thickness" on page 17. Trace the sashiko pattern on page 40 (or another one of your choosing) onto the 10" square of muslin and baste or spray baste it to the 10" navy blue square.

2. Stitch the design with the decorative thread in your bobbin.

3. Referring to "Machine Appliqué" on page 22, or using your favorite method, prepare the white crane appliqué pieces on page 39. Don't forget to reverse the crane templates if you want your crane to be facing the same direction as my sample; see "About-Face" on page 35 for my method. Appliqué the crane to the right side of the navy blue square.

4. Draw a circle with a radius of 4¼" onto the uncoated side of a 9" square of freezer paper. Cut on the drawn line. We will use this as a template to cut out our circle—circles made with a compass are easier to draw onto freezer paper than onto fabric.

5. Iron the freezer-paper circle to the wrong side of the appliquéd 10" square, being careful to center the motif. Cut around the freezer-paper circle and remove the paper.

6. Fold the 18" square of focal fabric in half twice and finger press to mark the center. Then center and fuse or baste the circle to your focal fabric. With a decorative stitch on your machine, appliqué the circle to the square. You might want to use foundation paper for stability if you are using a satin stitch. If you have not fused the two pieces together, trim the excess focal fabric from behind the circle, leaving a ¼" seam allowance.

7. Layer the square of batting, the backing, and the quilt top together and baste with pins or fuse if you're using fusible batting.

8. Quilt as desired.

9. Referring to "Basic Binding" on page 29, use the 2½" navy blue strips to bind the edges of the quilt.

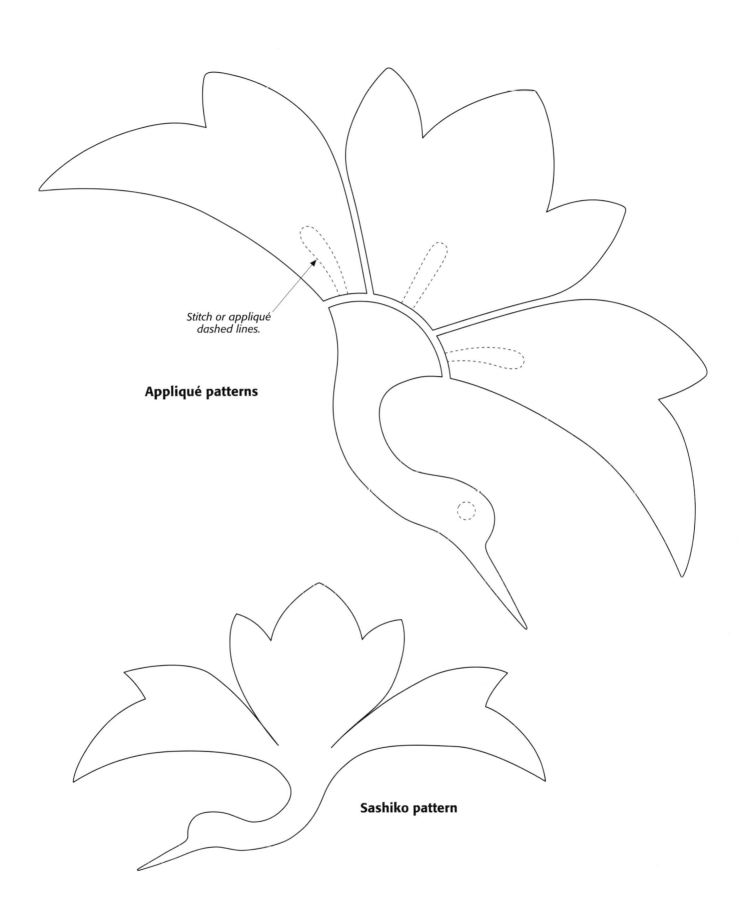

*Stitch or appliqué
dashed lines.*

Appliqué patterns

Sashiko pattern

Hanging Diamond: Two Variations

I have always loved quilts with a square set on point in the center. I call this square a Hanging Diamond. I've made quite a few over the years and have included two here. The background of triangle squares is common to both quilts, but with subtle differences in color and value placement you can achieve quite different looks.

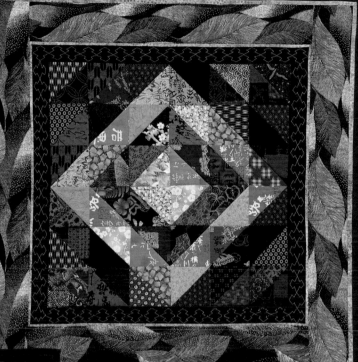

Hanging Diamond 2

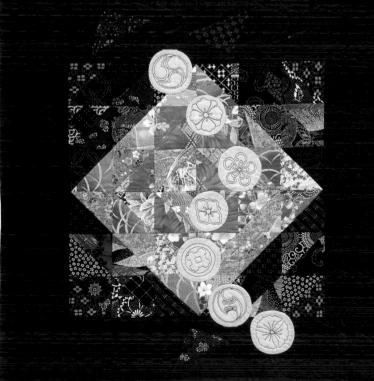

Hanging Diamond 1

Hanging Diamond 1

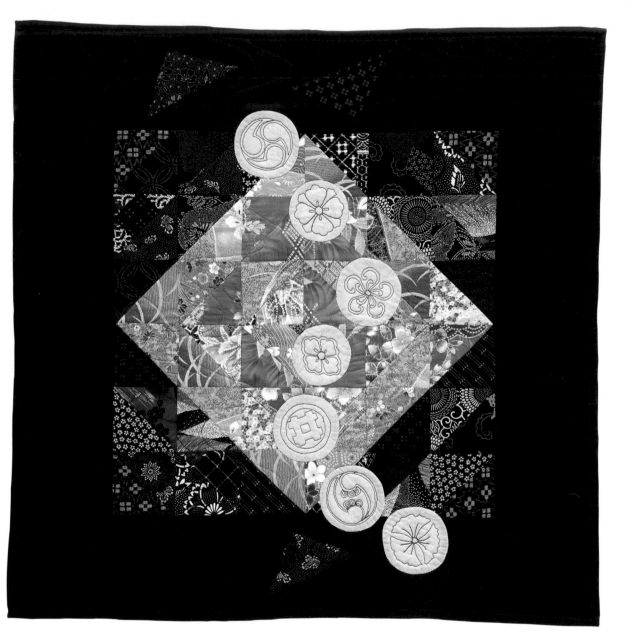

Quilt size: 36" x 36"

In this brighter blue version, I added seven appliquéd circles with family crests machine quilted on them. The single, wide border provides an opportunity to feature a special fabric or can serve as a background for some subtle sashiko quilting.

Materials

Yardage is based on 42"-wide fabric.

1⅛ yards of navy blue for border and binding

⅝ yard *total* of assorted light prints for triangle squares

⅝ yard *total* of assorted dark prints for triangle squares

1 fat quarter of light blue for circles

1¼ yards of fabric for backing

40" x 40" piece of batting

Water-soluble stabilizer sheet (such as Solvy)

Freezer paper

Compass for drawing circles with a 2" radius

Cutting

From the assorted light prints, cut:

18 squares, 4⅞" x 4⅞"; cut each square once diagonally to yield 36 triangles

From the assorted dark prints, cut:

18 squares, 4⅞" x 4⅞"; cut each square once diagonally to yield 36 triangles

From the navy blue, cut:

2 strips, 6½" x 24½"

2 strips, 6½" x 36½"

4 strips, 2½" x 42"

Assembly

1. Referring to the photograph on page 42, arrange the light and dark triangles on a design wall. When you have a pleasing arrangement, sew the triangles together in pairs to make the triangle squares.

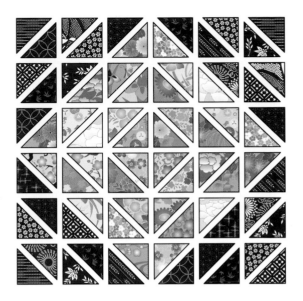

2. Press the seams toward the darker fabric. (When you sew the squares together, you may have to re-press the seams in the opposite direction in some of them.)

3. Return the triangle squares to your design wall and sew them into rows. Sew the rows together. Press the seams in one direction, alternating from row to row.

4. Sew the 6½" x 24½" navy blue border strips to the sides of your quilt. Press the seams toward the border.

5. Sew the 6½" x 36½" navy blue border strips to the top and bottom of your quilt. Press.

Appliquéd Circles

1. Trace the seven designs from pages 48–49 onto the right side of the light blue fabric, leaving at least 1½" between the designs.

2. Place the water-soluble stabilizer under the fabric and stitch the designs, referring to "The Ins and Outs of Stitching" on page 17 and "Sashiko on a Single Thickness," also on page 17.

3. Dissolve the stabilizer, following the manufacturer's directions, and press the fabric gently after it dries.

4. Using a compass, draw a circle with a radius of 2" onto the uncoated side of a piece of freezer paper. Cut on the drawn line. Make 7.

5. Iron the freezer-paper circles to the wrong side of the light blue fabric, centering them over the stitched motifs. Cut out the circles, adding between ⅛" and ¼" seam allowance.

6. Follow the directions for "Machine Appliqué— My Version" on page 22 to prepare and appliqué the circles. Use the photograph of the quilt on page 42 as a placement guide.

7. From the wrong side, trim inside the circles, leaving ¼" seam allowance, and remove the freezer paper.

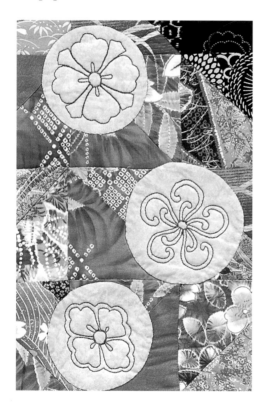

Optional Appliquéd Triangles

When I cut out the triangles for the pieced part of the quilt, I had a few left over and decided that I wanted to use them to soften the look of the navy blue border. I used fusible web to attach them to the border fabric and then did a simple zigzag stitch around the edges with a matching thread.

Quilting and Finishing

After making several navy blue quilts with white stitching, I decided to try something a bit subtler in this one. For the borders, I chose a navy blue heavy thread to quilt a beautiful design that looks like flowing water. However, unless you are up very close you can't see it. I think you'll agree that it is possible to be too subtle. The design is wonderful, but I suggest using a thread that has more contrast so that it will be more visible.

1. Trace the border design from page 48 onto the 6" borders of the quilt. You may also choose another design for the border. Just remember to choose a design with very few "dead ends" if you are machine quilting.

2. Layer the square of batting, the backing, and the quilt top together and baste with pins or fuse if you're using fusible batting. Quilt the center as desired. Quilt the marked border design, referring to "The Ins and Outs of Stitching" on page 17.

3. Referring to "Basic Binding" on page 29, use the 2½" navy blue strips to bind your quilt.

Hanging Diamond 2

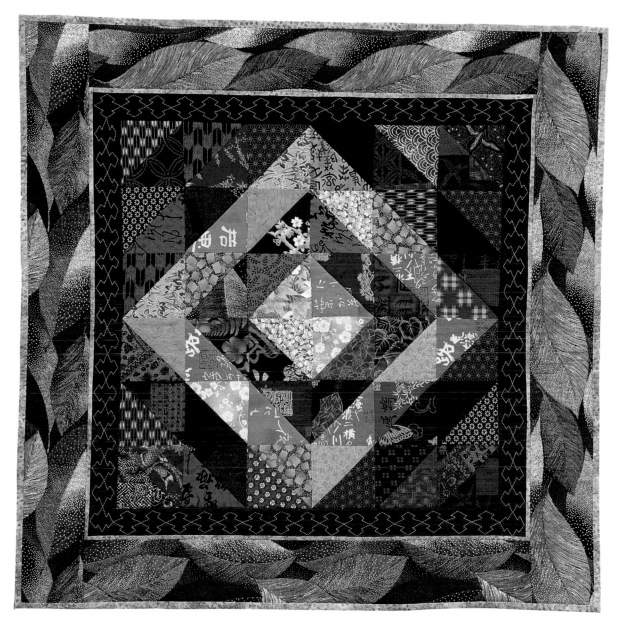

Quilt size: 36" x 36"

In this green and blue Hanging Diamond quilt, I wanted the setting to stand out more without the distraction of the appliquéd circles. I used a different border treatment, breaking the 6" border down into a 2"-wide inner border and a 4"-wide outer border with faux piping between the two.

Materials

Yardage is based on 42"-wide fabric.

⅝ yard *total* of assorted dark blue prints for triangle squares

⅜ yard *total* of assorted light green prints for triangle squares

¼ yard *total* of assorted dark green prints for triangle squares

⅝ yard of leaf print for outer border

⅜ yard of navy blue for inner border

¼ yard of light green print for faux piping

1¼ yards of fabric for backing

⅜ yard of fabric for binding

40" x 40" piece of batting

Cutting

From the assorted dark blue prints, cut:
18 squares, 4⅞" x 4⅞"; cut each square once diagonally to yield 36 triangles

From the assorted light green prints, cut:
12 squares, 4⅞" x 4⅞"; cut each square once diagonally to yield 24 triangles

From the assorted dark green prints, cut:
6 squares, 4⅞" x 4⅞"; cut each square once diagonally to yield 12 triangles

From the navy blue fabric, cut:
2 strips, 2½" x 24½"
2 strips, 2½" x 28½"

From the light green print for faux piping, cut:
4 strips, 1" x 42"

From the leaf print, cut:
2 strips, 4½" x 28½"
2 strips, 4½" x 36½"

Assembly

1. Referring to the photograph on page 45 and to the diagram at top right, arrange the light green, dark green, and dark blue triangles on a design wall. When you have a pleasing arrangement, sew the triangles together in pairs. Press the

seams toward the darker fabric (when you sew the squares together, you may have to re-press the seams in the opposite direction in some of them).

2. Return the triangle squares to your design wall and sew them into rows. Sew the rows together.
3. Sew a 2½" x 24½" navy blue strip to each side of your quilt. Press toward the navy blue strip.
4. Sew a 2½" x 28½" navy blue strip to the top and bottom of your quilt. Press.
5. For the faux piping, fold each 1" x 42" strip in half lengthwise with wrong sides together and press.
6. Align the raw edges of a folded faux piping strip to the raw edges of opposite sides of your quilt and sew with a *scant* ¼" seam. Trim the ends of the faux-piping strips even with the top and bottom of the quilt. Do not press the seams.

Folded edge

Raw edges →

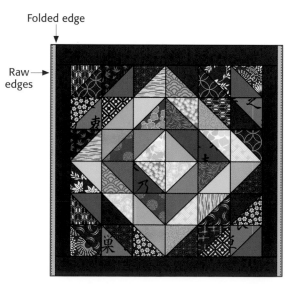

7. Repeat step 6 to add piping strips to the top and bottom of the quilt.

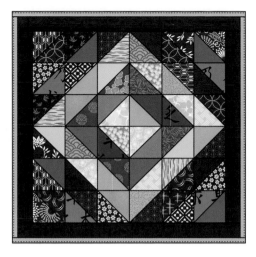

8. Add the 4½" x 28½" leaf print border pieces to the sides of the quilt, making sure your stitches will hide the faux-piping stitching line. Press the seams toward the leaf print border. Add the 4½" x 36½" leaf print borders to the top and bottom. Press.

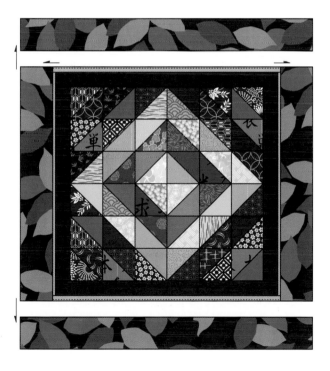

Quilting and Finishing

1. Referring to "Marking" on page 11 and using the Pine Bark pattern on page 48, mark the designs on the 2" navy blue border before layering.
2. Layer, baste, and quilt as desired.
3. Referring to "Basic Binding" on page 29, bind your quilt.

Marking and Fitting

I made a full-sized paper template of the border of the quilt and traced the Pine Bark sashiko design (page 48) onto it before transferring the design to the quilt. That way I knew it would fit—and also where I might have to stretch or squeeze the design slightly to make sure it did. I put the paper design right next to the fabric border and used a plastic template to mark the quilt. Just stitch through any small gaps to connect the designs in one continuous line of stitching.

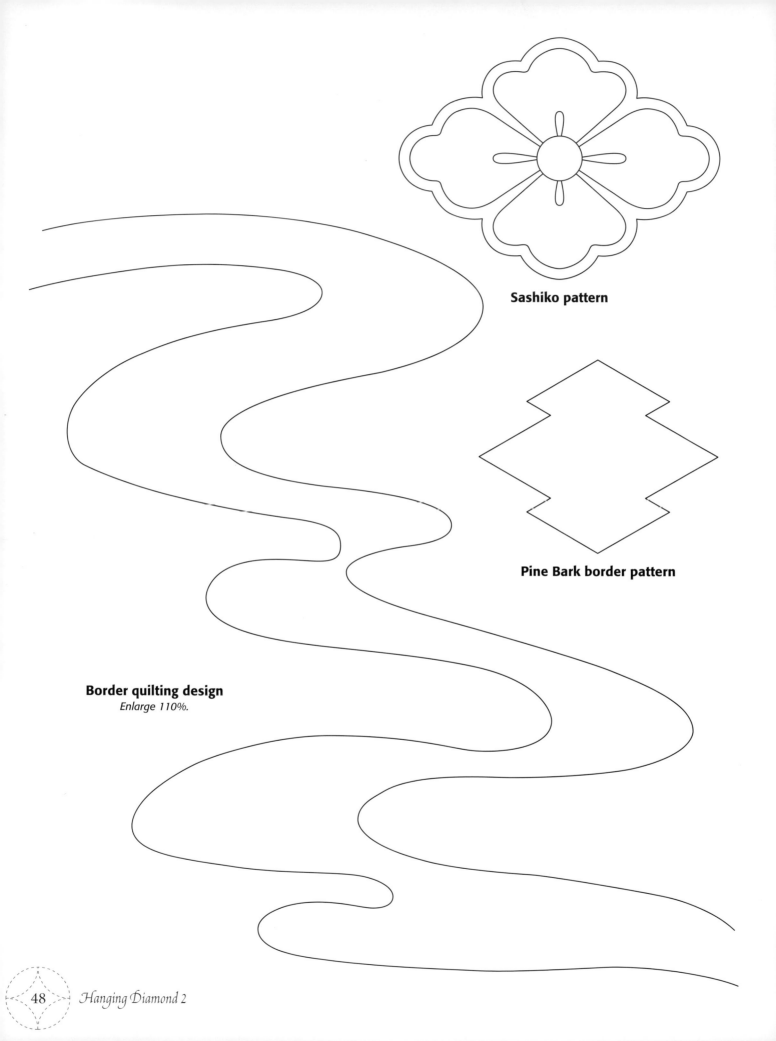

Sashiko pattern

Pine Bark border pattern

Border quilting design
Enlarge 110%.

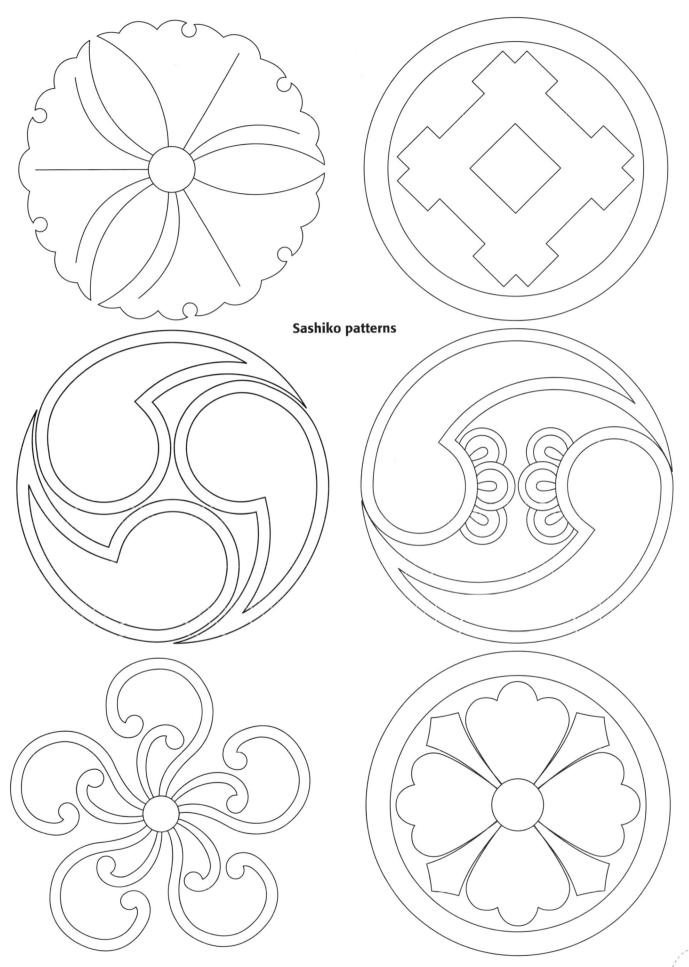

Sashiko patterns

Red-and-Black Beauty

Quilt size: 18" x 42"

In spite of the fact that many of these Japanese designs are hundreds of years old, I think these three look very contemporary, particularly the crane in the center. When I went looking for a name for the motifs in the top and bottom sections, I could only find them referred to as "commas." It seems like such a mundane name for these very beautiful, fluid designs.

I used faux piping to outline the three black squares, but it is optional. I think it gives a nice crisp edge to the background squares and it clearly defines the edge of the blocks.

The top square has three identical commas placed so that they go over and under each other. I made life simple for myself and appliquéd them as complete commas, layering the appliqués rather than breaking them into two pieces. You can cut the template into two pieces if you wish.

Materials

Yardage is based on 42"-wide fabric.

¾ yard of black fabric for background and binding

⅝ yard of red-and-black print for sashing and borders

⅝ yard of red fabric for appliqués and faux piping

1⅜ yards of fabric for backing

21" x 45" piece of batting

Freezer paper

Cutting

From the black fabric, cut:

3 squares, 10½" x 10½"

4 strips, 2½" x 42"

From the red fabric, cut:

4 strips, 1" x 42"

From the red-and-black print, cut:

2 pieces, 2½" x 10½"

2 pieces, 4½" x 34½"

2 pieces, 4½" x 18½"

From the backing fabric, cut:

1 piece, 21" x 45"

Assembly

1. Make appliqué templates by tracing the patterns on pages 53–55 onto the uncoated side of freezer paper. Referring to "Invisible Machine Appliqué" on page 24 or using your preferred method, appliqué the red motifs onto the three 10½" x 10½" black squares. Use the appliqué placement guides to help you position the designs.

2. For faux piping, fold each 1" x 42" strip of red fabric in half lengthwise with wrong sides together and press. Align the raw edges of a folded strip with the raw edges of opposite sides of each background square and sew with a scant ¼" seam. Trim the ends even with the top and bottom of the background square. Do not press the seam. Repeat for the remaining sides of the three background squares.

3. Sew the 2½" x 10½" pieces of red-and-black print to the bottom of the top two blocks.

4. Join the three blocks.

5. Sew the 4½" x 34½" red-and-black print pieces to the sides of the quilt. Press the seams toward the borders.

6. Sew the 4½" x 18½" red-and-black print pieces to the top and bottom of the quilt. Press toward the border.

7. Layer the batting, the backing, and the quilt top together and baste with pins or fuse if you're using fusible batting. Quilt as desired.
8. Referring to "Basic Binding" on page 29, bind your quilt.

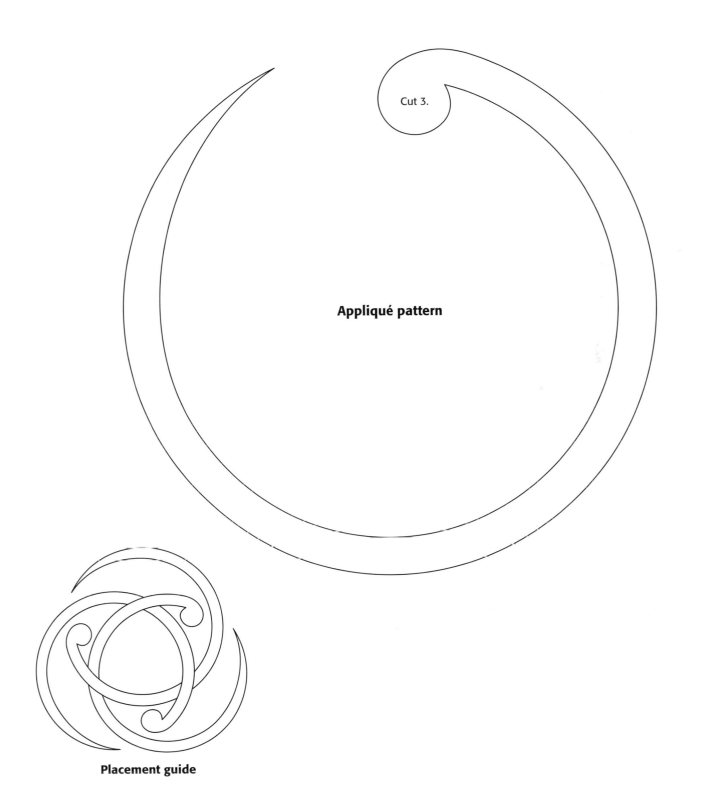

Cut 3.

Appliqué pattern

Placement guide

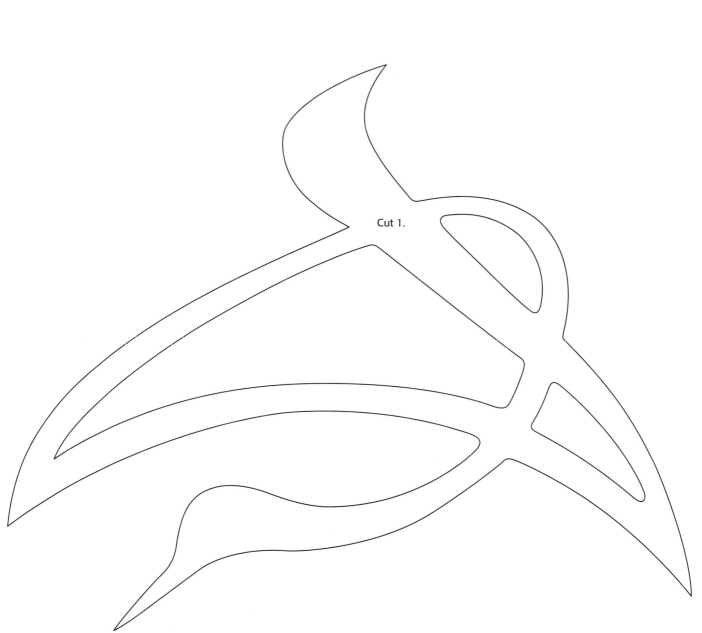

Cut 1.

Appliqué pattern

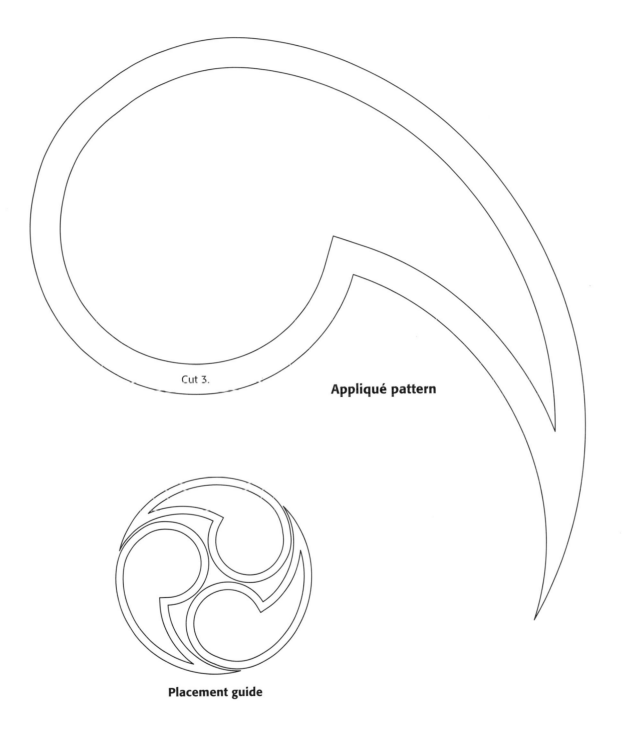

Cut 3.

Appliqué pattern

Placement guide

Sashiko Table Runner

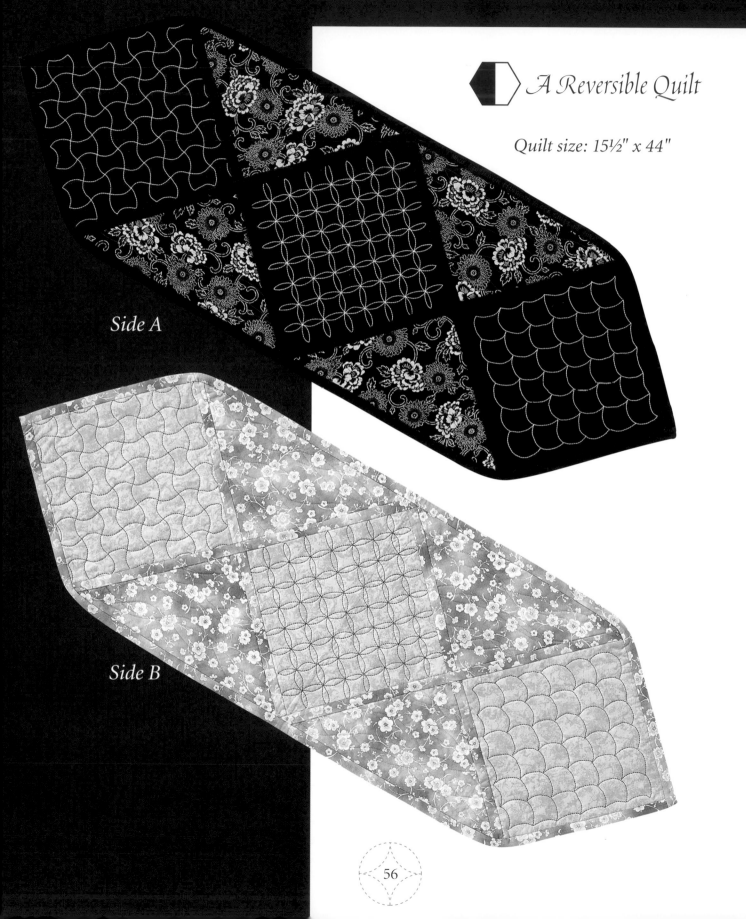

A Reversible Quilt

Quilt size: 15½" x 44"

Side A

Side B

I have a great fondness for table runners. You can make them quickly so you can have a collection to change as often as you wish, and they are a wonderful gift. It doesn't dip too deeply into your stash to make one and most people appreciate them. For this table runner, I put the sashiko patterns on point. This is a wonderful project to both practice your stitching and discover the joys of the reversible method.

Materials

Yardage is based on 42"-wide fabric.

Side A

½ yard of navy blue fabric for sashiko blocks

1 fat quarter of blue-and-white print for setting triangles

Side B

½ yard of pink fabric for sashiko blocks

1 fat quarter of green-and-pink print for setting triangles

Basic Sashing

⅛ yard for 1⅛"-wide strips

¼ yard for 1¾"-wide strips

Basic Binding

⅜ yard

Reversible Binding

¼ yard for 1⅛"-wide strips

¼ yard for 1¾"-wide strips

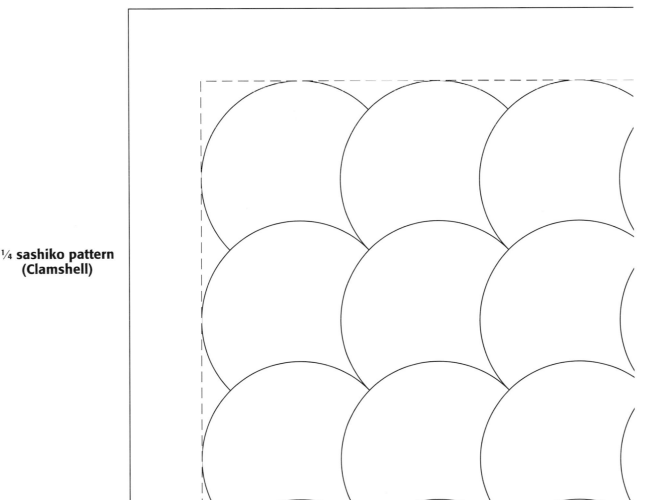

¼ sashiko pattern (Clamshell)

Batting

⅓ yard of 96"-wide batting

Cutting

From the navy blue fabric *and* the pink fabric, cut:

3 squares from *each,* 10½" x 10½"

From the batting, cut:

3 squares, 10½" x 10½"

1 square, 15½" x 15½"; cut the square twice diagonally to yield 4 triangles

From the blue-and-white print *and* the green-and-pink print, cut:

1 square from *each,* 15½" x 15½"; cut each square twice diagonally to yield 4 triangles (8 total)

Assembly

1. Mark the sashiko designs on the three navy blue 10½" blocks using the patterns on pages 57–59. Refer to "Marking" on page 11. Remember that the blocks will be trimmed before they are sewn into the quilt so the area to be quilted will finish at 9" x 9". The designs that I used are the 2" Clamshell, a 1⅝" circle for Seven Treasures of Buddha, and a 1⅝" Counterweights design.

2. Layer a 10½" batting square between a side A and side B 10½" square; fuse or baste together.

3. Stitch the designs with a heavyweight thread of your choice.

4. Trim the blocks to 10" x 10".

5. Layer a batting triangle between a side A and side B setting triangle; fuse or baste and quilt as desired.

**¼ sashiko pattern
(Seven Treasures
of Buddha)**

6. Referring to "Basic Sashing" on page 20, cut sashing strips for sides A and B. Join the blocks into diagonal rows as shown in the diagram. Join the rows.

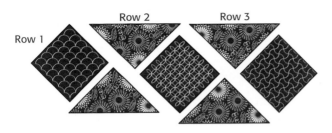

Row 1 Row 2 Row 3

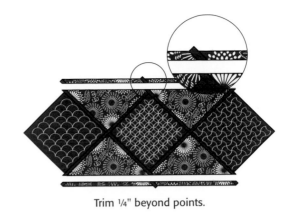

Trim ¼" beyond points.

7. Trim the long sides of the setting triangles and round the corners if desired. Rounding the corners will make the binding go on easier.

8. Referring to "Basic Binding" on page 29 or "Reversible Binding" on page 31, cut strips and bind the edges of the quilt.

Round corners if desired.

**¼ sashiko pattern
(Counterweights)**

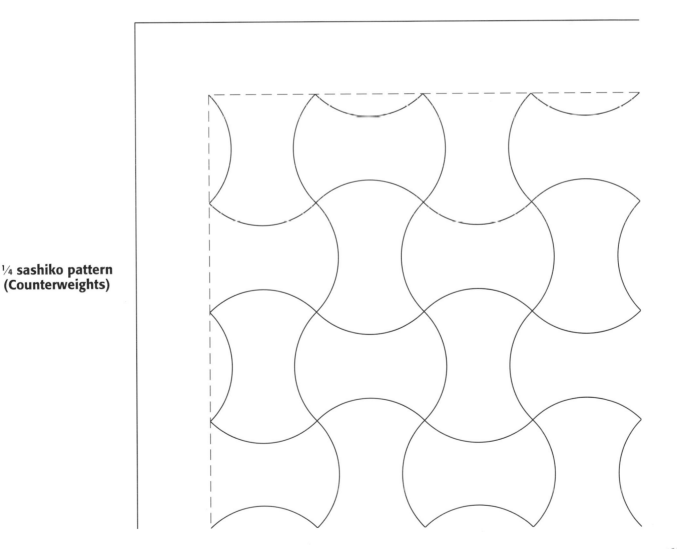

Sashiko Sampler

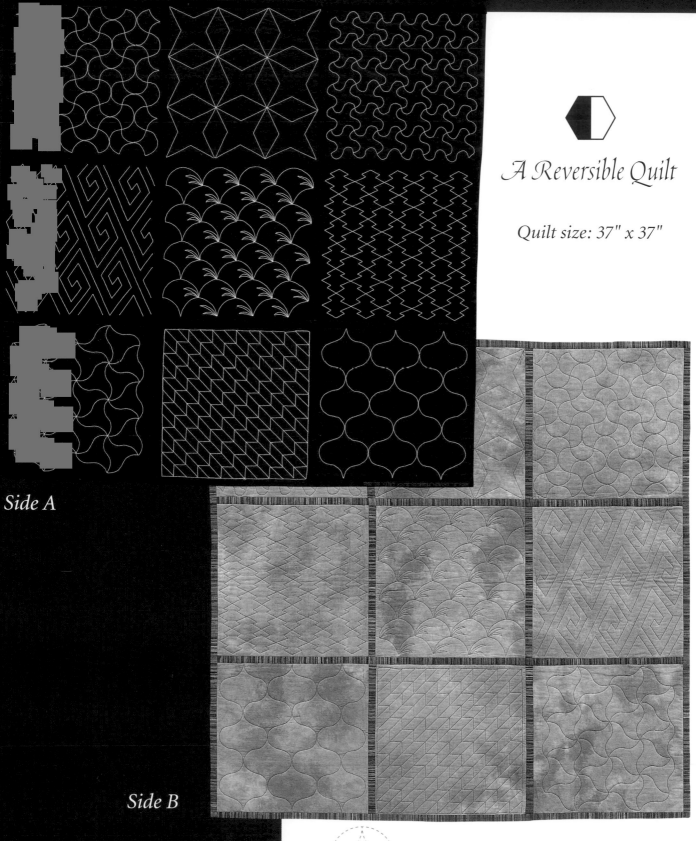

A Reversible Quilt

Quilt size: 37" x 37"

Side A

Side B

When I was first asked to teach sashiko by machine, I decided to make a sampler in order to practice a variety of patterns. In it I made all sorts of mistakes and learned a lot. I think the major lesson was to scale the individual patterns to fit the size of the block. I decided that my blocks would have looked much better if they had complete motifs around the edges and not ones that had been decapitated. I scoured my sashiko books and chose nine favorites to use in my "new and improved" sampler. I wanted a mixture of straight and curved lines and a variety of scale. So, some of the stitching patterns in this quilt are quite dense and in other blocks the pattern is more open and light.

This is another reversible quilt—mind you I almost never bother to show the back. I made it using the reversible technique more for the convenience than the desire to have a reversible quilt. There is so much pivoting in the making of this quilt that I wouldn't consider doing it any other way.

You'll notice that in eight of the nine blocks I was able to enclose each motif; that is, the design is centered in the block and I don't have any of the design cut in half around the edge. The one holdout is the left block in the middle row. Unlike the other motifs I chose, this one—called Lightning in my reference book—has no beginning or end. It is a continuous-line pattern that makes it impossible to have it end at the edge of the block.

Materials

Yardage is based on 42"-wide fabric.

Side A

1½ yards of navy blue fabric for blocks and sashing

Side B

1¼ yards of pink fabric for blocks

⅜ yard of striped fabric for sashing

Basic Binding

⅜ yard of navy blue fabric

Reversible Binding

⅜ yard of navy blue fabric

⅜ yard of striped fabric

Batting

⅞ yard of 96"-wide batting

Cutting

From the navy blue fabric, cut:
9 squares, 13" x 13"

From the pink fabric, cut:
9 squares, 13" x 13"

From the batting, cut:
9 squares, 13" x 13"

> ### Drafting Fun
> I used isometric graph paper from Karen Combs to draft the Lightning pattern used in block 4 (left block, middle row). If you enjoy drafting your own designs, I suggest that you try this paper for angular designs. See "Resources" on page 111 for details.

Making the Blocks

1. Referring to "Marking" on page 11 and using the patterns on pages 63–69, mark the nine patterns on the navy blue squares.
2. Layer the marked squares with 13" x 13" batting and pink backing squares; fuse or baste the three layers together.
3. Referring to "The Ins and Outs of Stitching" on page 17, stitch the designs.
4. Trim each block to 12½" x 12½".

Assembly

1. Referring to "Basic Sashing" on page 20, sew the blocks together in three rows of three.
2. Sew the rows together with sashing strips.
3. Referring to "Basic Binding" on page 29 or "Reversible Binding" on page 31, bind the quilt.

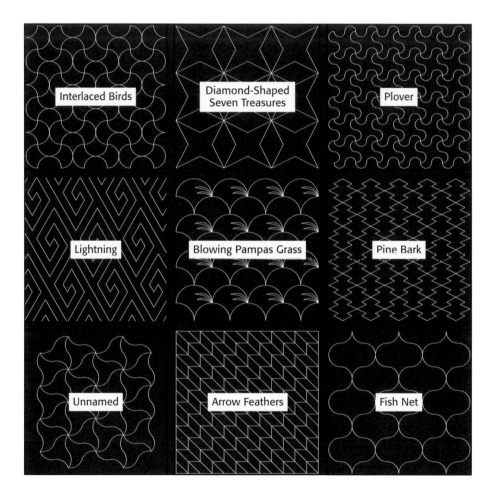

Note: I have tried in vain to find a name for the pattern used in block 7 (lower left corner). It is not in any of my sashiko books. I used a stencil from StenSource (W1017) that is available in different sizes. Permission has been kindly granted to include the design for your use. See "Resources" on page 111.

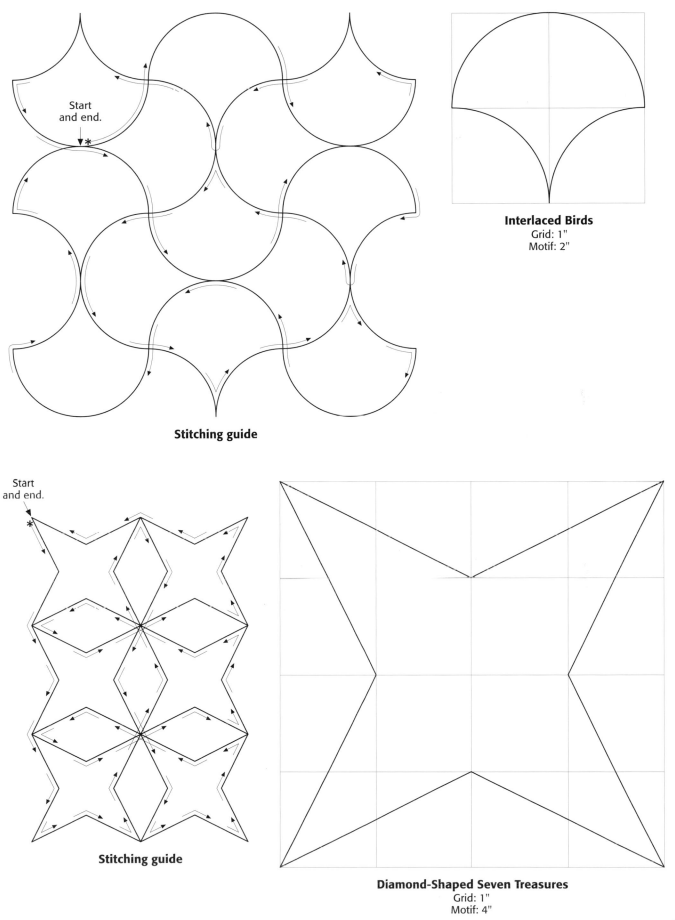

Start and end. ✱

Stitching guide

Interlaced Birds
Grid: 1"
Motif: 2"

Start and end. ✱

Stitching guide

Diamond-Shaped Seven Treasures
Grid: 1"
Motif: 4"

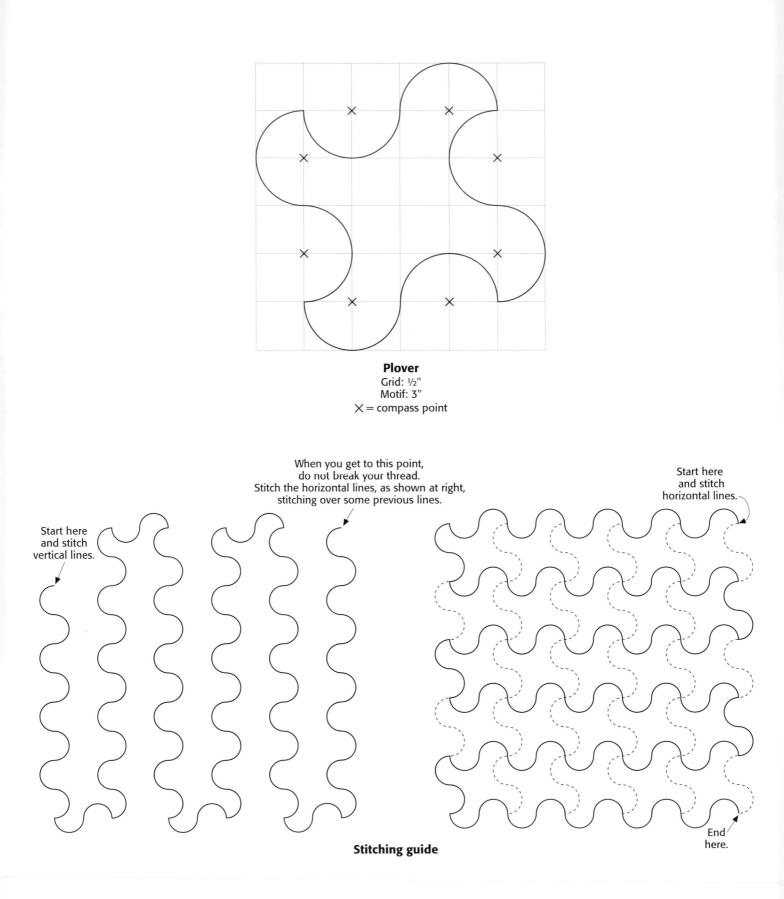

Plover
Grid: ½"
Motif: 3"
✕ = compass point

When you get to this point,
do not break your thread.
Stitch the horizontal lines, as shown at right,
stitching over some previous lines.

Start here
and stitch
horizontal lines.

Start here
and stitch
vertical lines.

End
here.

Stitching guide

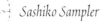

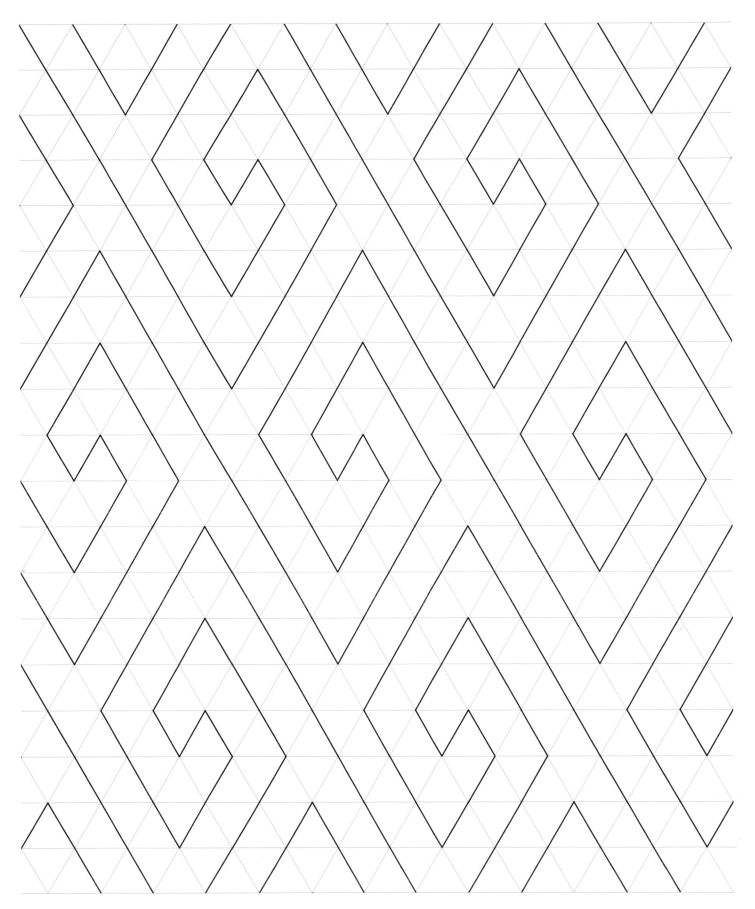

Lightning

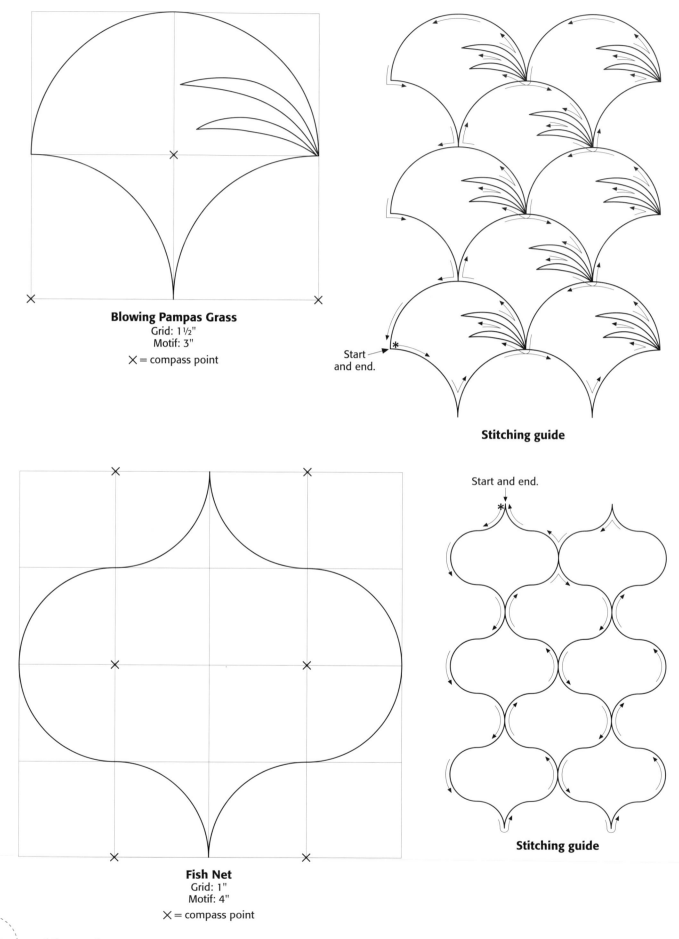

Blowing Pampas Grass
Grid: 1½"
Motif: 3"

X = compass point

Start
and end.

Stitching guide

Start and end.

Fish Net
Grid: 1"
Motif: 4"

X = compass point

Stitching guide

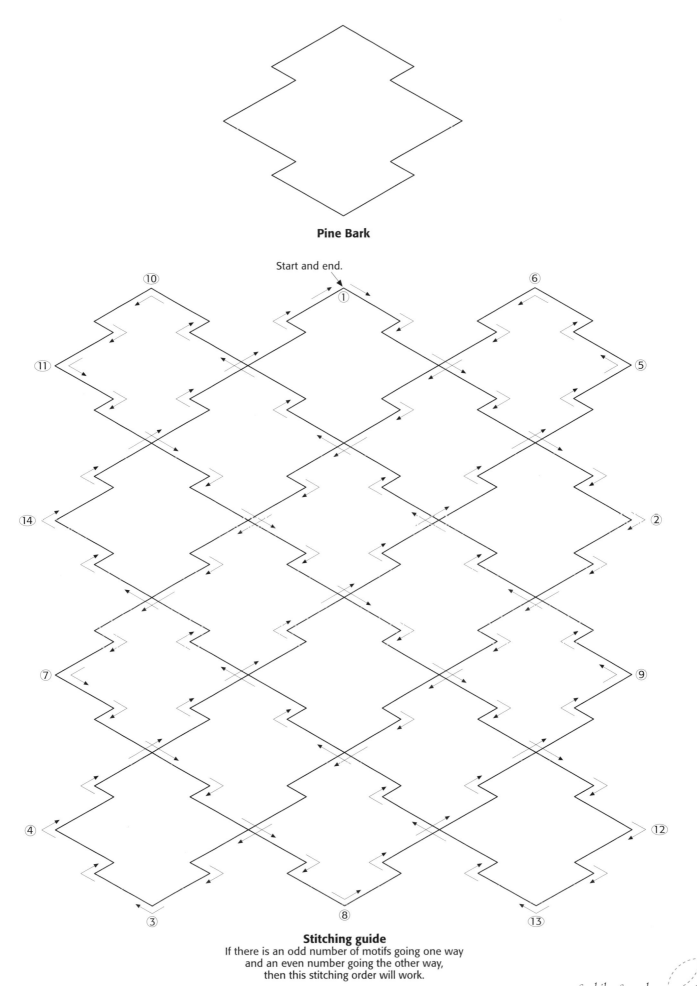

Pine Bark

Start and end.

Stitching guide
If there is an odd number of motifs going one way
and an even number going the other way,
then this stitching order will work.

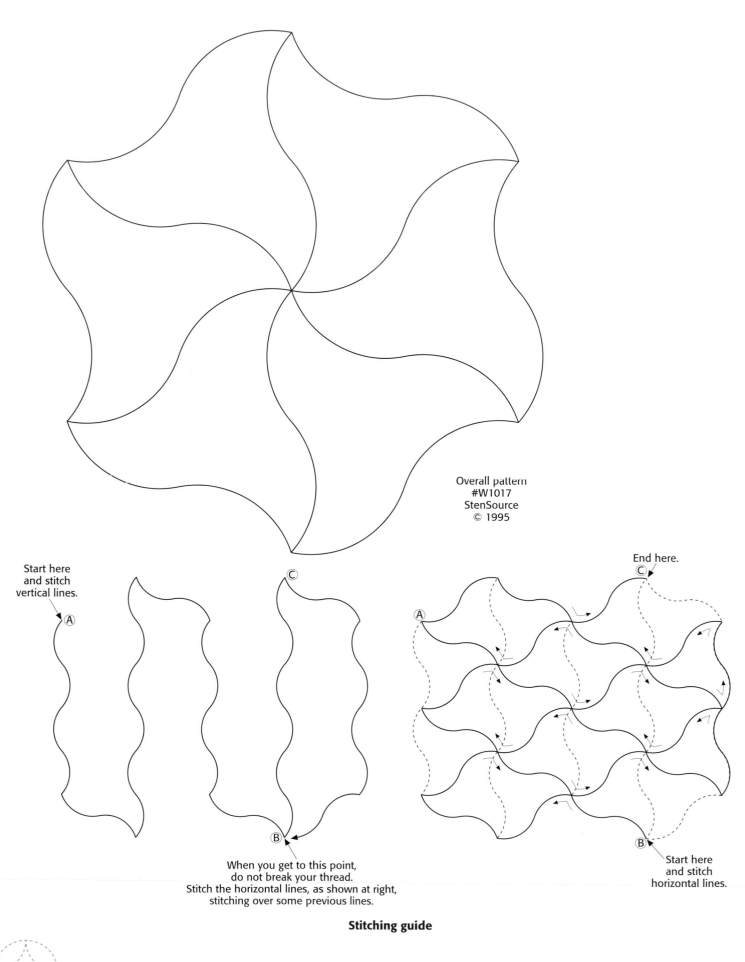

Overall pattern
#W1017
StenSource
© 1995

Start here
and stitch
vertical lines.

Ⓐ

Ⓒ

End here.

Ⓒ

Ⓐ

Ⓑ

When you get to this point,
do not break your thread.
Stitch the horizontal lines, as shown at right,
stitching over some previous lines.

Ⓑ

Start here
and stitch
horizontal lines.

Stitching guide

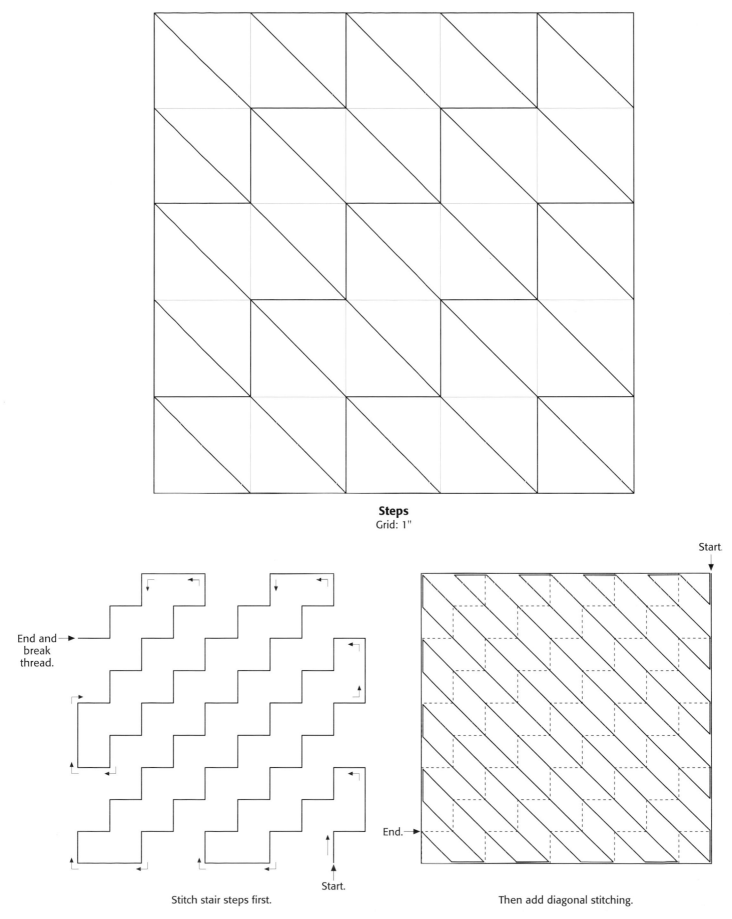

Steps
Grid: 1"

End and break thread.

Start.

Stitch stair steps first.

Start.

End.

Then add diagonal stitching.

Stitching guide

Ginkgo Leaves: Two Variations

Ginkgo Leaves 1

Have you ever had an experience where you see things grouped together—accidentally—that lead you in a direction you hadn't gone before? One day while cleaning up my worktable, I happened to see three things lying together that led to this wall hanging. They were a hexagon template from another project, the buckles I used in variation I, and a group of ginkgo patterns. I decided that I would like to use the buckles to join the three blocks instead of the usual sashing strips that I had been using. I had been saving the ginkgo patterns for something special but I didn't quite know what. Serendipity—don't you just love it when things fall together like that?

Ginkgo Leaves 2

Ginkgo Leaves 1

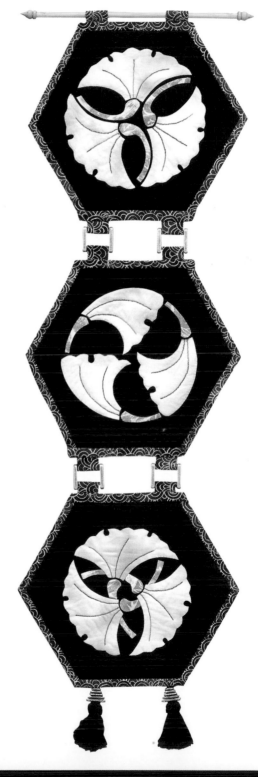

Quilt size: 12" x 38"

My advice is to decide on the hanging rod before you cut the tabs to attach it with. I thought it would be easy to find a bamboo hanging rod that would fit in the tabs, so I blithely sewed them on the top block. Many trips to town later, I realized that I should have bought the hanging rod first. I know I could have removed the tabs and made new ones, but tell me, how many of you enjoy doing that kind of thing? I ended up using a bamboo knitting needle that was cut to size, and fitted with an extra knob that is removable so I could slide it through the tabs.

Materials

Yardage is based on 42"-wide fabric.

½ yard of navy blue fabric for background

⅜ yard of beige tone-on-tone fabric for leaves

⅛ yard of coordinating off-white print for stems

½ yard of fabric for backing

½ yard of fabric for binding and hanging tabs

⅜ yard of 96"-wide batting, or a 16" x 40" piece (I used Hobbs Heirloom Fusible Cotton Batting)

4 buckles

2 tassels (optional)

Bamboo hanging rod

Freezer paper

Compass for drawing a circle with a 6¼" radius

Making the Hexagon Template

Refer to "Drawing Hexagons" on page 75. Set your compass to a radius of 6¼" and draw a 12½" hexagon on template plastic or cardboard. See "Drawing Large Circles" on page 26 if your compass is not big enough. Change the radius of your compass to measure 5¾" to draw an 11½" hexagon within the first one. Place the compass point in the center of the circle you just drew. This will give you two cutting lines, one to cut out the hexagons and the smaller one to trim your blocks to after they are quilted. Use the outer edge of the hexagon template to cut the background, batting, and backing.

11½"

12½"

Cutting

From the navy blue fabric, cut:
3 hexagons

From the backing fabric, cut:
3 hexagons

From the batting, cut:
3 hexagons

Appliqué

1. Refer to "Machine Appliqué" on page 22 or use your preferred appliqué technique. Make templates from the three ginkgo leaf patterns on pages 78–79 and prepare the appliqués.
2. Appliqué the motifs onto the navy blue hexagons, following the appliqué placement guides on pages 78–79. Please note the stitching order on ginkgo leaf 3. The stem pieces should be appliquéd first, followed by the leaf pieces. The edges indicated by an asterisk will not need to be turned under because they will be covered by the leaves.

Assembly and Finishing

1. Layer each hexagon with the batting and backing. Baste and quilt as desired.
2. Add stitching details to the leaves. I used a 40-weight variegated thread and a narrow zigzag stitch. I stitched from the base of the leaf to the tip and back again with the feed dogs down. Doing the stitching free-motion gives a natural, organic look.

3. Align the hexagon template with the outside edges of your blocks and mark the inside line

with a washable marker. Trim ¼" beyond the marked lines.

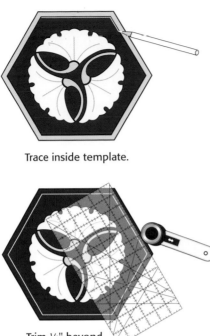

Trace inside template.

Trim ¼" beyond drawn line.

Mitering Help
These corners are 120° angles, and to miter them I find the Binding Miter Tool designed by Jackie Robinson invaluable. See "Resources" on page 111 for details.

4. From the binding fabric, cut two strips, each 2½" x 42"; fold the strips in half lengthwise with the wrong sides together and press. Referring to the diagram, bind edges B, C, E, and F on blocks 1 and 2. Bind edges B, C, D, E, and F on block 3. The remaining sides will use reversible binding so that the tabs can be sewn into the seam allowances.

5. Referring to "Reversible Binding" on page 31, prepare reversible binding strips for sides A and D on blocks 1 and 2 and side A on block 3. Do not sew the strips together.

6. Determine the width of fabric needed to make tabs for the buckles and the hanging rod by measuring the length of the bar on the buckle. Double the length of the bar and add ½". My buckle bar was 1¼", so the width should be 3" (1¼" x 2" = 2½" + ½" = 3").

1¼ × 2 + ½ = 3"

7. From the binding fabric, cut a 20" strip to the width determined in step 6. Fold in half lengthwise with wrong sides together and sew the long edges with a ¼" seam. Press the seam open and center it in the middle of one side; press. (If you prefer, you can sew the strip right sides together, and turn the resulting tube right-side out.)

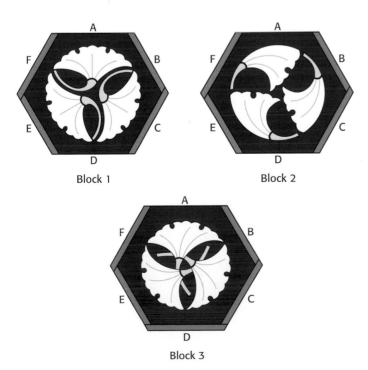

Block 1

Block 2

Block 3

8. Cut ten 2" pieces from the strip made in step 7 and wrap one around a buckle bar with the seam allowance on the inside.

9. Determine the placement of the tabs and mark the placement on each reversible binding strip. There's no specific measurement; place the tabs where they look best to you. Lay two tabs with buckles on the right side of the 1⅛" binding strip, lining up the raw edges; cover with the folded binding strip. Pin in place and sew with a ¼" seam.

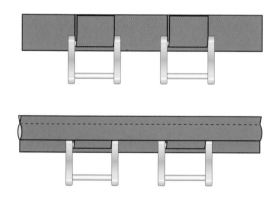

10. Repeat step 9 for another pair of tabs and buckles. Then you will need to add tabs to the other side of the buckles and sew them to a second set of reversible binding strips as you did before.

11. Referring to "Reversible Binding" on page 31, sew a binding strip between each of the blocks to join them.

12. Repeat step 9 with the remaining two tabs (without buckles) to create hanging tabs for the top of the wall hanging. Add the binding to the top of the wall hanging.
13. Add tassels to the bottom block, if desired, and insert a bamboo hanging rod through the top tabs.

Drawing Hexagons

To draw hexagons, first draw a circle with a radius that is half the distance from point to point on your desired hexagon. The length of the radius will also be the length of each side.

½ of desired size = radius of circle to draw

Desired size of hexagon

1. For a hexagon that is 12" from top to bottom, set your compass at 6" (that will be the radius). Draw a circle on template plastic or cardboard. See "Drawing Large Circles" on page 26 if your compass is not big enough.

6"

2. Move the point of the compass to the point on the circle that is directly above the center.

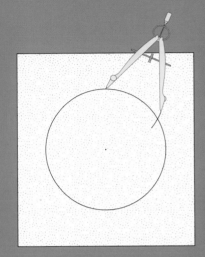

3. Without changing the compass, mark the circle and move the compass point to that mark and mark the circle again. Connect the two points to make the first side of your hexagon.

4. Continue to mark around the circle and connect the marks until you have six sides.

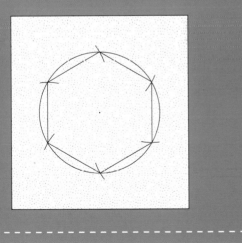

Ginkgo Leaves 2

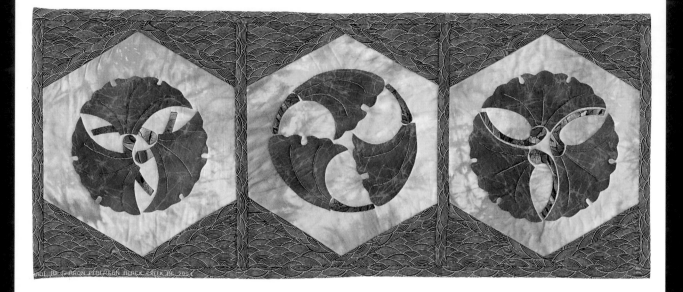

 A Reversible Quilt

Quilt size: 31½" x 14"

When I finished "Ginkgo Leaves 1," I wondered what it would look like if I changed the orientation of the hexagons so that they had pointed tops instead of flat tops. I arranged the blocks in a horizontal setting, which I found quite pleasing, and took the opportunity to work with a different color palette. I used the reversible-block technique to make the stitching easier, not because I intended to show off the back. Use whatever fabrics you want on side B—even plain muslin would be okay.

Materials

Yardage is based on 42"-wide fabric.

¾ yard of black-and-gold print for setting triangles, sashing, and binding (side A)

¾ yard of fabric for setting triangles, sashing, and binding (side B)

½ yard of yellow print for appliqué background (side A)

½ yard of fabric for hexagons (side B)

⅜ yard of green print for leaves

⅛ yard of brown print for stems

⅜ yard of 96"-wide batting (I used Hobbs Heirloom Fusible Cotton Batting)

Cutting

Refer to "Making the Hexagon Template" for Variation 1 on page 72 to make a hexagon template.

From the yellow print, cut:
3 hexagons

From the black-and-gold print, cut:
2 strips, 4¼" x 22½"; layer the strips right sides together and crosscut into 6 rectangles, 4½" x 7½"

From the fabric for hexagons (side B), cut:
3 hexagons

From the fabric for the setting triangles, sashing, and binding (side B), cut:
2 strips, 4¼" x 22½"; layer the strips right sides together and crosscut into 6 rectangles, 4½" x 7½"

From the batting, cut:
3 hexagons
2 strips, 4¼" x 22½"; layer the strips right sides together and crosscut into 6 rectangles, 4½" x 7½"

Assembly

1. Refer to "Appliqué" and steps 1–3 of "Assembly and Finishing" on page 72 for "Ginkgo Leaves 1." Follow the instructions, but make sure you have the point of the hexagons at the top of the blocks for this wall hanging.

2. Layer the 4¼" x 7½" black-and-gold print rectangles together in pairs with wrong sides together; cut each pair once diagonally to yield a total of 12 triangles. Repeat with the fabric for side B and the batting.

3. Layer a batting triangle between a front triangle and back triangle and fuse or baste. Quilt as desired. I didn't do any quilting in the triangles because they were very small. The minimum distance between quilting lines for Hobbs Heirloom Fusible Cotton Batting is every 4½", which is larger than the finished triangles.

4. Referring to "Basic Sashing" on page 20, sew the triangles to the hexagons as shown. Trim the units, if needed, so that the edges are straight and the corners are square.

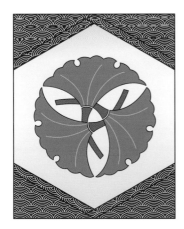

5. Join the blocks with sashing strips. Referring to "Reversible Binding" on page 31 or "Basic Binding" on page 29, cut binding strips and bind your quilt.

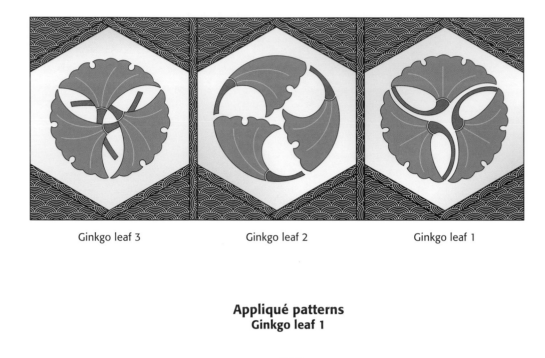

Ginkgo leaf 3 Ginkgo leaf 2 Ginkgo leaf 1

Appliqué patterns
Ginkgo leaf 1

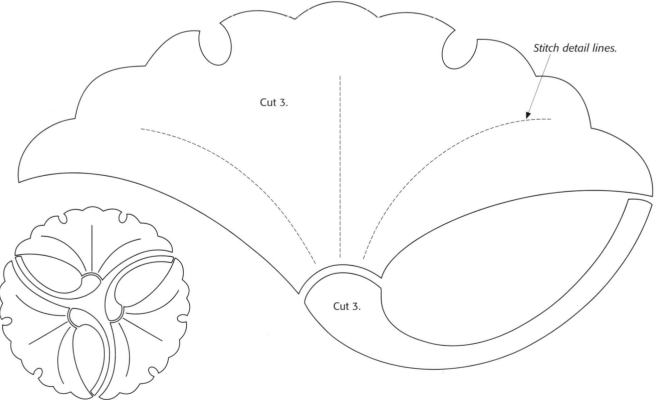

Stitch detail lines.

Cut 3.

Cut 3.

Placement guide

Appliqué patterns

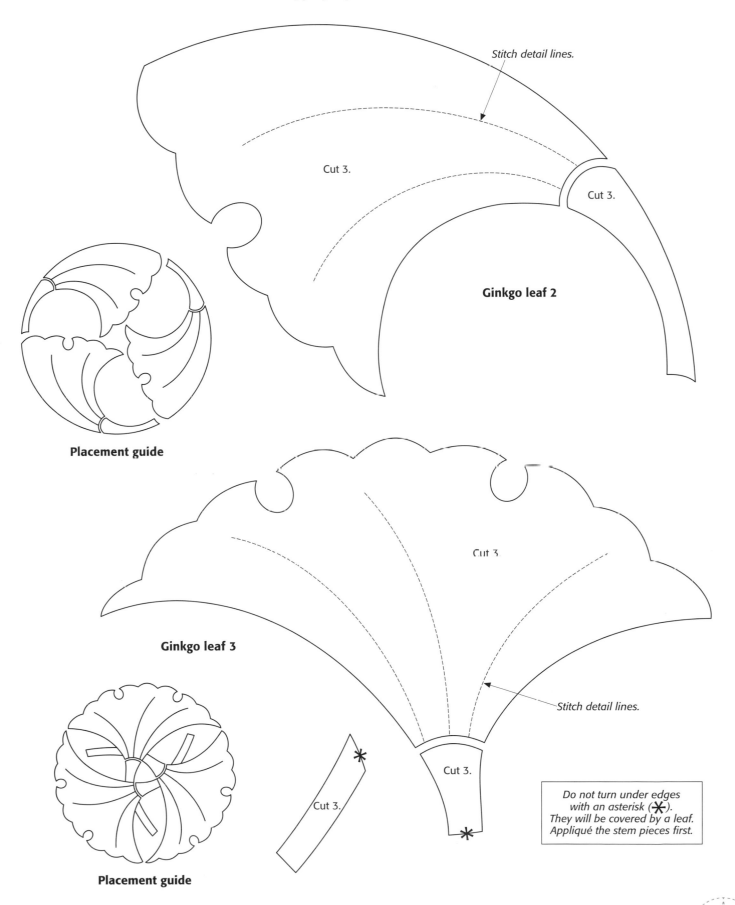

Stitch detail lines.

Cut 3.

Cut 3.

Ginkgo leaf 2

Placement guide

Ginkgo leaf 3

Cut 3

Stitch detail lines.

Cut 3.

Cut 3.

Do not turn under edges with an asterisk (✻). They will be covered by a leaf. Appliqué the stem pieces first.

Placement guide

Touched by Japan

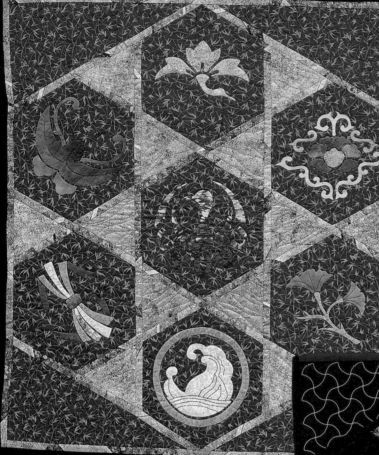

Side A

 A Reversible Quilt

Quilt size: 31" x 36"

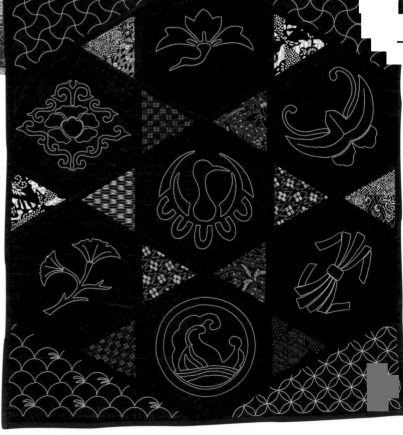

Side B

This reversible quilt is one of my all-time favorites. I have made several different versions of it, but for this one, I chose crest patterns that would look good as appliqué patterns on side A and as sashiko patterns on side B. As you know from reading "My Approach to Machine Sashiko" on page 6 (you have read those instructions, haven't you?), it's much easier to do the sashiko on a small block because you can pivot the pieces easily.

On side B—the side with sashiko stitching—you can see both the bobbin and needle thread. The four corner sashiko designs were sewn with the decorative white thread in the needle, whereas the family-crest designs were sewn from the other side with the decorative thread in the bobbin. It is the same thread in both cases.

Materials
Yardage is based on 42"-wide fabric.

Side A
1⅜ yards of blue print for hexagons and corner triangles

⅝ yard of gold print for setting triangles and sashing

Assorted scraps for appliqué

Side B
1⅝ yards of navy blue fabric for hexagons, sashing, and corner triangles

12 pieces, 7" x 8", of assorted navy blue prints for setting triangles*

If you want all the setting triangles to be from the same fabric, you will need ½ yard of a blue-and-white print.

Basic Binding
⅜ yard

Reversible Binding
¼ yard for 1⅛"-wide strips

⅜ yard for 1¾"-wide strips

Batting and Supplies
⅝ yard of 96"-wide fusible batting

Compass for drawing circles with a 6" radius

13" square of transparent template plastic or cardboard

Cutting
From the gold print, cut:*
2 strips, 5⅞" x 42"

From the batting, cut:
2 rectangles, 9" x 15½"; cut each rectangle once diagonally to yield 4 corner triangles
1 strip, 5⅞" x 96"

From *both* the blue print (side A) and the navy blue (side B), cut:
2 rectangles, 9" x 15½"; place right sides together and cut once diagonally to yield 4 triangles

If you are using just one fabric for the setting triangles on Side B, cut that fabric into 2 strips, 5⅞" x 42" also.

Cutting the Setting Triangles

1. Cut 12 triangles from the 5⅞" strips of gold print fabric using the 60° mark on your ruler as shown. If you are using a single fabric for side B, cut it the same way. If you are using several different fabrics, follow step 3.

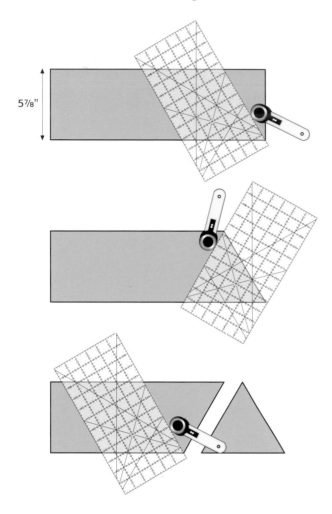

2. Cut 12 triangles from the batting strip in the same manner.
3. If you are using different fabrics for the setting triangles on side B as I did, make a triangle template from the pattern on page 91. Cut one triangle from each of the twelve 7" x 8" pieces of navy blue print fabric.

Making the Hexagon Template

1. Refer to "Drawing Hexagons" on page 75. Set your compass to a radius of 6" and draw a 12" hexagon on template plastic or cardboard. See "Drawing Large Circles" on page 26 if your compass is not big enough.
2. Change the radius of your compass to measure 5¾" and draw a second hexagon within the first one. Place the compass point in the center of the circle you just drew. This will give you two cutting lines: one to use to cut out the hexagon fabrics and the smaller one to trim your blocks after they are quilted.

3. Cut on both the drawn lines. Trace around the outer edge to draw seven hexagons each onto the blue print for side A, the navy blue fabric for side B, and the batting. Cut the hexagons using a rotary cutter and ruler or scissors.

Side A

1. Make appliqué templates using the patterns on pages 39 and 84–89.
2. Referring to "Machine Appliqué" on page 22 or using your preferred appliqué technique, appliqué the seven motifs to the blue print hexagon pieces.
3. Layer a batting hexagon between a side A and side B hexagon fabric and fuse; baste if using regular batting.
4. Thread your machine with a heavyweight white thread in the bobbin, such as YLI Jeans Stitch, and navy blue 50/3 cotton thread in the needle.
5. Put the walking foot on your machine and use an 80/12 universal needle. Quilt in the ditch around the appliqué pieces and add interior

stitching details as indicated. Repeat for all seven blocks.

6. Using the inside line on your hexagon template as a guide, trim the seven blocks.

Side B

1. Referring to "Marking" on page 11, mark the four sashiko designs on the four navy blue corner triangles using the patterns on pages 90–91. The four I chose are all 2" designs drawn on a 1" grid. I suggest doing a trial on paper to establish your pattern before marking the fabric.

Before You Fuse
If you are using fusible batting, don't use the marking pencil that comes off when ironed. When you put the iron on the piece to fuse the batting, you will erase your sashiko design.

2. Layer the batting triangles between the side A and side B corner triangles and fuse or baste.

3. Thread your machine with a heavyweight white thread such as YLI Jeans Stitch in the needle (a 100/16 topstitching needle) and navy blue 50/3 cotton thread in your bobbin. Using a walking foot, stitch the designs in each corner triangle. Refer to "The Ins and Outs of Stitching" on page 17.

4. For the setting triangles, layer a batting triangle between a side A and a side B setting triangle; fuse or baste. Quilt as desired. Repeat for all 12 setting triangles.

Assembly

1. Arrange the blocks, setting triangles, and corner triangles on your design wall.

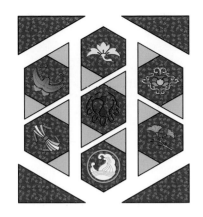

2. Referring to "Basic Sashing" on page 20, join the blocks and rows together as shown. Note that the setting and corner triangles are cut slightly larger than necessary so they will have to be trimmed after they are sewn in place. When joining the setting triangles to the hexagon blocks, center the triangle on the side of the hexagon and, when sewn in place, trim off any excess.

Center the triangle. Trim.

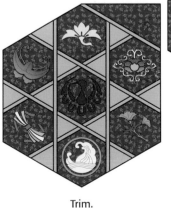

Trim.

3. Referring to "Basic Binding" on page 29 or "Reversible Binding" on page 31, cut strips and bind the edges of the quilt.

Hanging Sleeve

Where do you put a hanging sleeve on a reversible quilt? I insert it between the side A and side B binding at the top of the quilt. Measure and make the hanging sleeve, and referring to "Reversible Binding" on page 31, insert it between the two pieces of binding at the top of the quilt.

Appliqué patterns

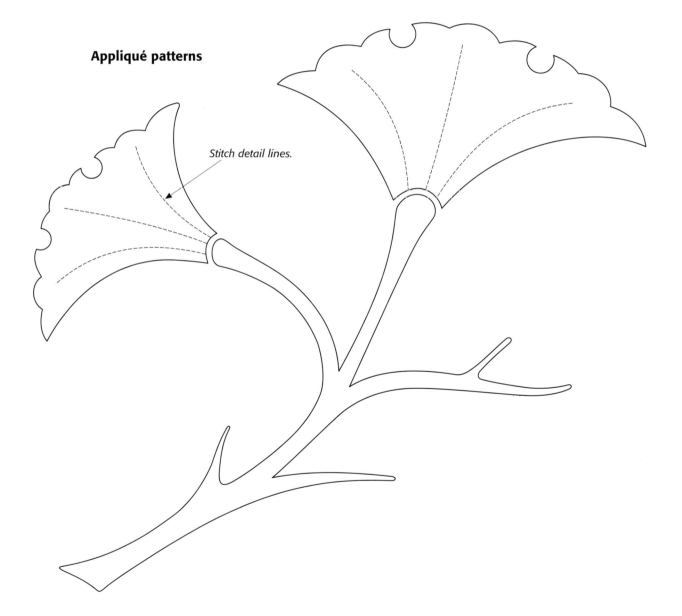

Stitch detail lines.

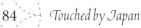

Appliqué patterns

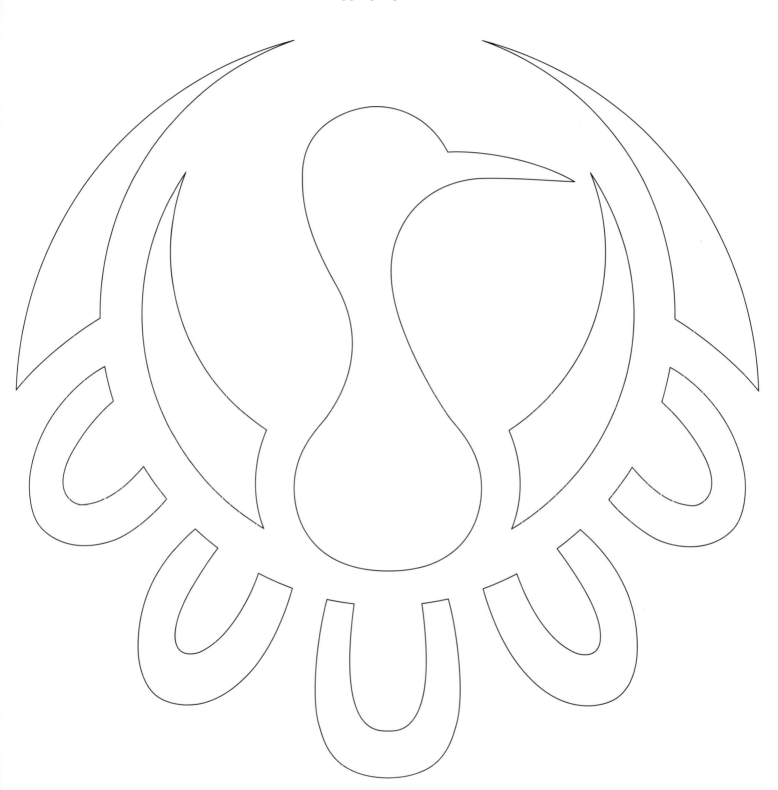

Appliqué patterns

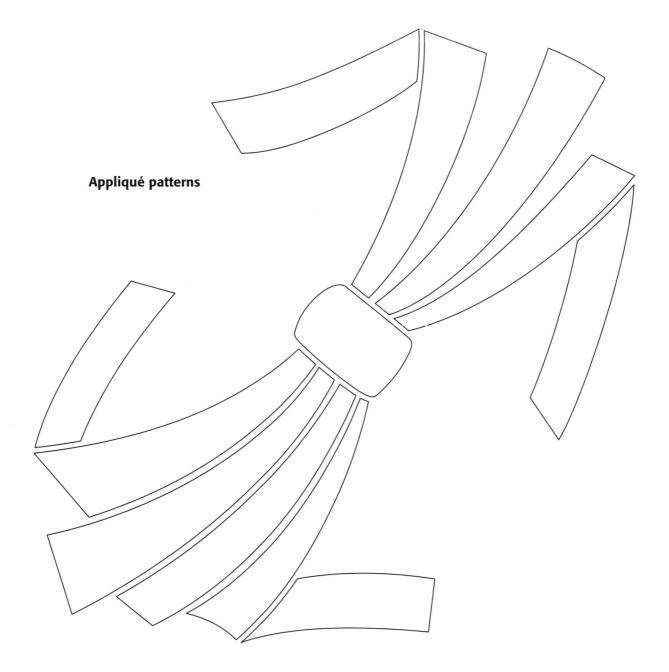

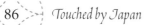

Appliqué patterns

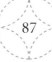

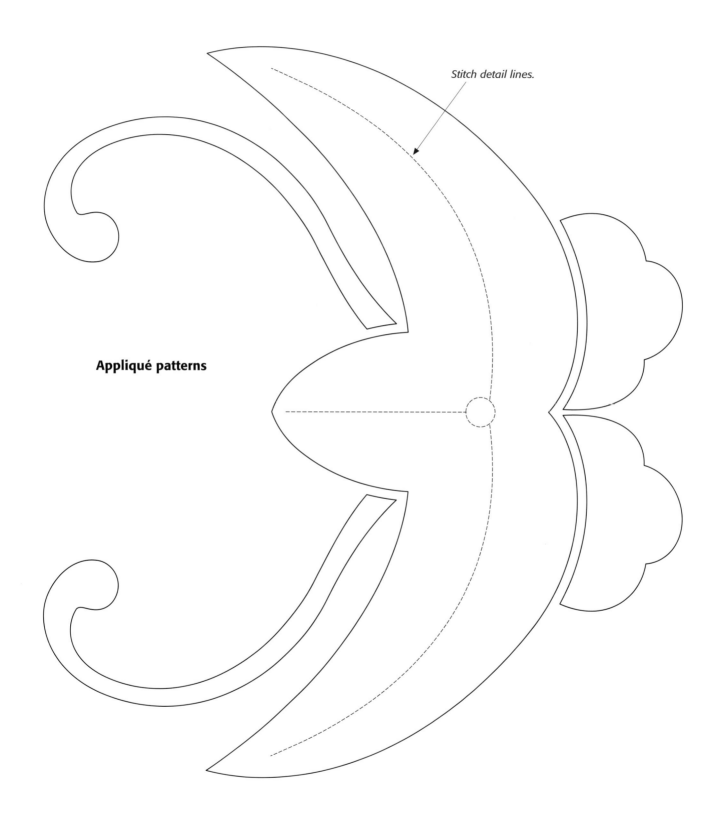

Stitch detail lines.

Appliqué patterns

Appliqué patterns

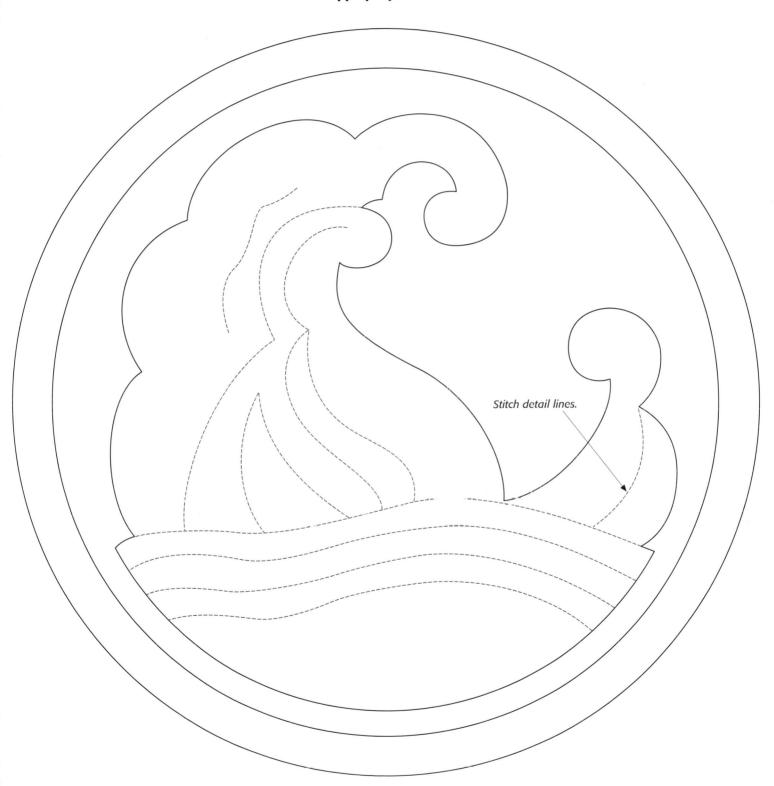

Stitch detail lines.

Sashiko patterns
 Grid: 1"
 Motifs: 2"

✕ = compass point

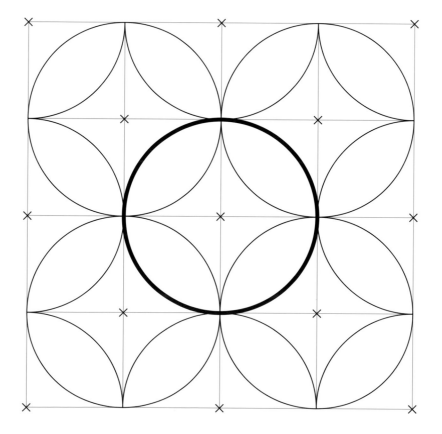

Touched by Japan

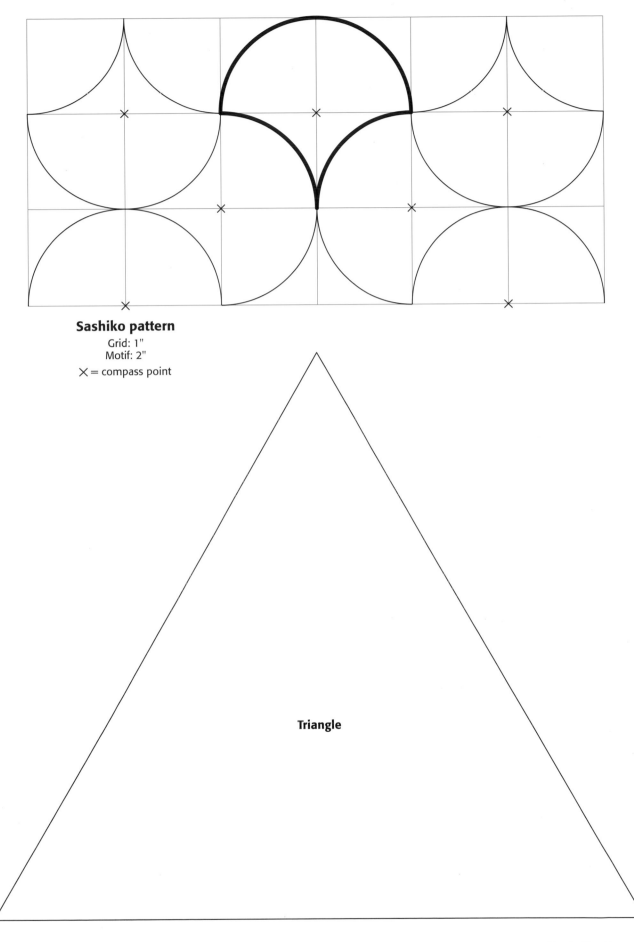

Sashiko pattern

Grid: 1"

Motif: 2"

✕ = compass point

Triangle

Red Kimono

Quilt size: 38" diameter

For a brief period in the late nineties, my friend Lynn McKitrick and I produced a line of quilting patterns. When Lynn decided to go back to school and I had to choose whether to carry on alone or not, the whole thing seemed more like work than the fun it had been when we worked together. So, we had a going-out-of-business sale and took ourselves out for dinner with the profits. This was one of our patterns: Lynn drew it, and I made it.

Materials

Yardage is based on 42"-wide fabric.

2 yards of black fabric for background, optional faux piping, and binding

1 fat quarter of red print for kimono and circle motifs

1 fat quarter of contrasting red print for kimono panels and circle motifs

1 fat quarter of gold fabric for kimono panels, cuffs, collar, and circle motifs

1⅜ yards of fabric for backing

42" x 42" piece of batting*

Freezer paper

Fusible web

30 to 38 yards of assorted heavy threads for couching

Needle with large eye for tying off couching threads

**Use a batting that does not require close quilting, such as Hobbs Organic Cotton Batting with Scrim.*

Cutting

From the black fabric, cut:
1 square, 42" x 42"
2½"-wide bias strips to total 132"

From the backing fabric, cut:
1 square, 42" x 42"

Kimono Appliqué

To provide more definition between the two different red prints in the kimono and enhance the visual impact, I added very narrow faux piping between the panels, the collar, the cuffs, and the main body of the kimono. To add the optional trim, cut two strips, ¾" x 42", from the black fabric. Fold the strips in half lengthwise with the wrong sides together and press.

1. Refer to "Machine Appliqué" on page 97 or use your favorite appliqué technique. Enlarge the kimono pattern on page 97; then trace it and the other pattern pieces for the kimono on page 96 onto freezer paper, marking asterisks where noted. The sides with asterisks do not need to be turned under because they will be covered by other appliqué pieces. Use a pin or other removable marker to mark the center of the kimono. Prepare the kimono appliqué pieces. Do not appliqué the circle motifs yet. They will be added using fusible web after the heavy threads are sewn on.

2. To add the faux piping, pin it in place and then tape the appliqué pieces over it.

3. Appliqué the kimono pieces to the black background fabric, working from bottom to top. Sew the outer panels and the collar piece on first, then the middle panels, followed by the cuffs, and finally, the body of the kimono.

4. Referring to "Drawing Large Circles" on page 26, place the compass point in the center of the kimono and draw a circle with a radius of 19" around it.

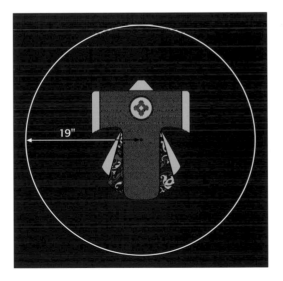

5. Layer the top, the batting, and backing fabric and fuse or baste.

6. Quilt around the kimono pieces. If you have used Hobbs Organic Cotton Batting with Scrim you can leave up to 8" unquilted, so no further quilting is required in the kimono.

Adding the Decorative Threads

Since you will be using a couching foot, rather than a walking foot, you will have to take extra precautions so that the layers won't slip when adding the decorative threads while you are machine quilting. Some extra basting or pins would be a big help. Another thing that helps is reducing the amount of pressure on your sewing machine's presser foot if that's possible on your machine. Set up your machine for couching, following the instructions in "Couching Heavyweight Thread" on page 95.

1. Begin closest to the center of the quilt. Pull a length of the decorative thread through the foot and hold onto it as you begin to stitch. Anchor the thread with very tiny stitches and then sew with a gentle wavy line around in a circle until you come back where you started. Anchor the thread again. Leave long tails at both the beginning and end of your stitching line. Using a needle with a large eye, pull the tails through to the back, tie a knot, and bury the ends in the batting as you do when quilting.

2. Repeat with as many threads as desired, working from the center to the outside edge of the quilt and making sure you stay at least ¼" inside the circle you drew on the quilt top. When all of the stitching is finished, you will trim on that line, so you want to leave room for your seam allowance.

Adding the Final Appliqué Motifs

1. Trace seven crest patterns and an assortment of circle patterns on pages 97–98 onto the paper side of fusible web, leaving at least ½" between each. I varied the background circles so that no two would be exactly the same.

2. Cut loosely around the designs and fuse them to the wrong side of the appropriate fabrics. Cut out the shapes on the drawn lines, remove the paper backing, and fuse the crests and circles to the quilt top, referring to the photograph on page 92 for placement.

3. Using either a satin stitch and decorative thread, or a narrow zigzag and invisible thread, stitch around the fused pieces. You will be stitching through all the layers, so use a walking foot on your machine.

Circular Diversions
Add rings to your circles, or fuse a doughnut shape (a circle with a hole in its center) onto a larger circle for variety.

4. Trim the excess fabric by cutting along the circle you drew on the quilt top.

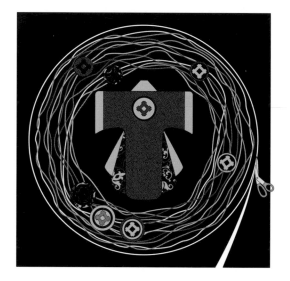

5. Join the 2½" black bias strips end to end, offsetting the points ¼" as shown. Press the seam open.

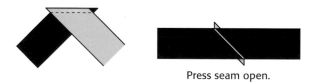

Press seam open.

6. Fold the binding in half lengthwise with wrong sides together and press.

7. Bind your quilt.

Couching Heavyweight Thread

For this you will need a couching foot on your machine. The foot has a large hole in the top just in front of the oval-shaped hole for the needle. The heavy thread is fed through the hole from the top, then under the foot and pulled to the back. Choose a stitch that goes from side to side—it can be a plain zigzag or a decorative stitch. Do some practice stitches with your couching thread and your needle thread to find the prettiest combination. I wanted only the couched thread to show so I used an ordinary zigzag stitch with invisible thread in the needle.

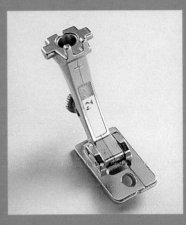

Couching foot

To easily feed the thread from the spool, I threaded the spool onto the knee lift on my machine. If you don't have a knee lift or if you are using spools that won't fit on it, use a plastic straw with a rubber band wound round the end to hold the spool. Insert the open end under the front of the machine (the weight of the machine will keep it in place).

Multiple strands of decorative threads can be stitched at the same time. This allows you to create your own color scheme or special effect. Keeping the couching thread from getting tangled can sometimes be a problem, so I created a guide using a piece of cardboard and a hole punch. Count the number of threads you plan to use and put a hole for each one in the cardboard. Tape the cardboard to the front of your machine and thread each piece through a hole. With this system, I am able to handle three or four threads simultaneously.

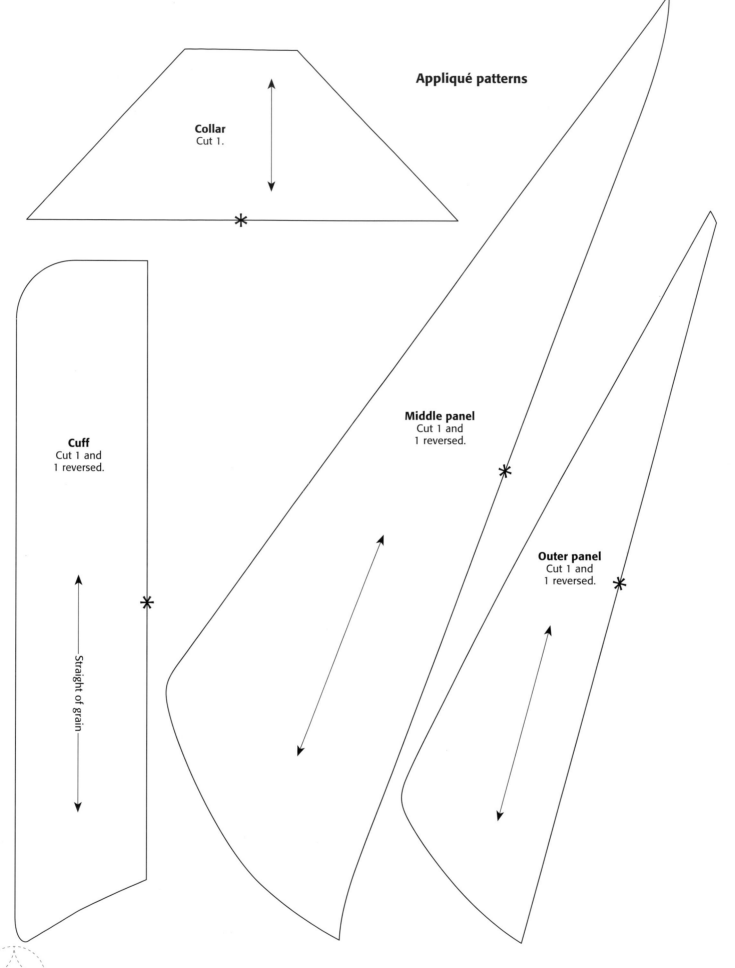

Appliqué patterns

Collar
Cut 1.

Cuff
Cut 1 and
1 reversed.

Straight of grain

Middle panel
Cut 1 and
1 reversed.

Outer panel
Cut 1 and
1 reversed.

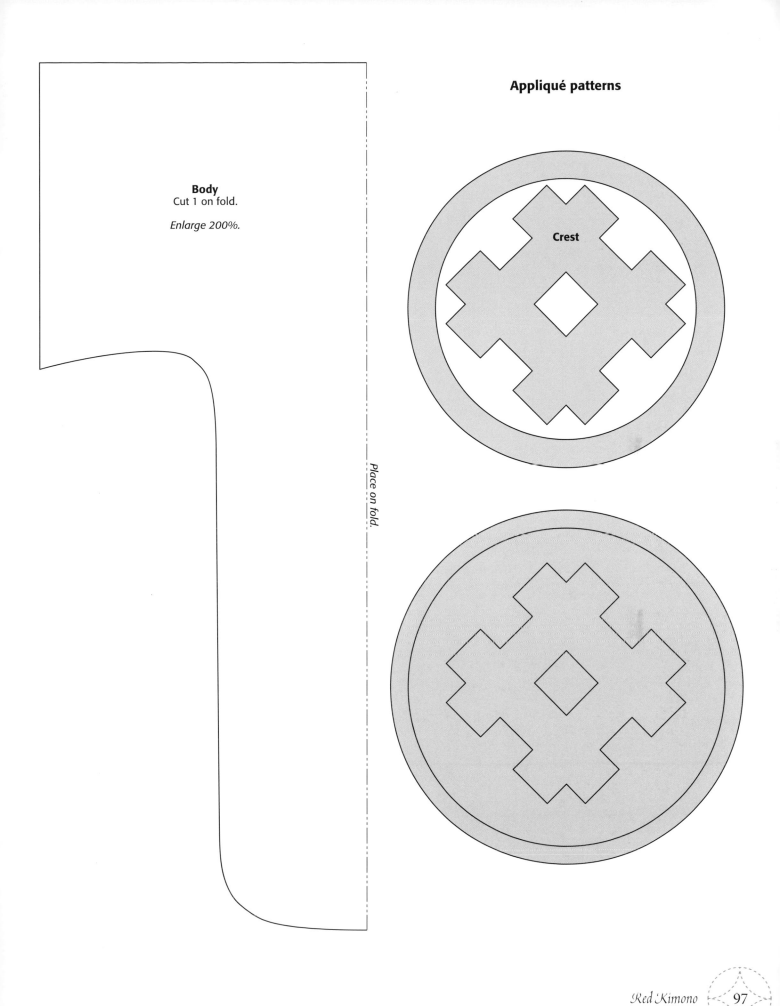

Body
Cut 1 on fold.

Enlarge 200%.

Place on fold.

Appliqué patterns

Crest

Appliqué patterns

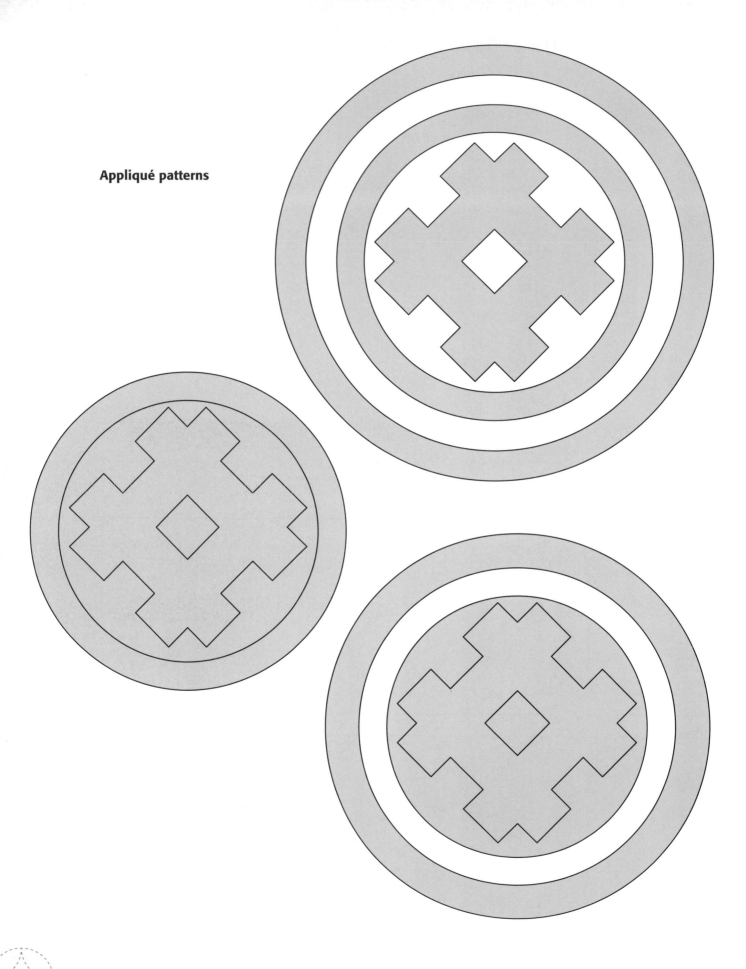

Praise to Pippen

A Reversible Quilt

Quilt size: 51" x 51"

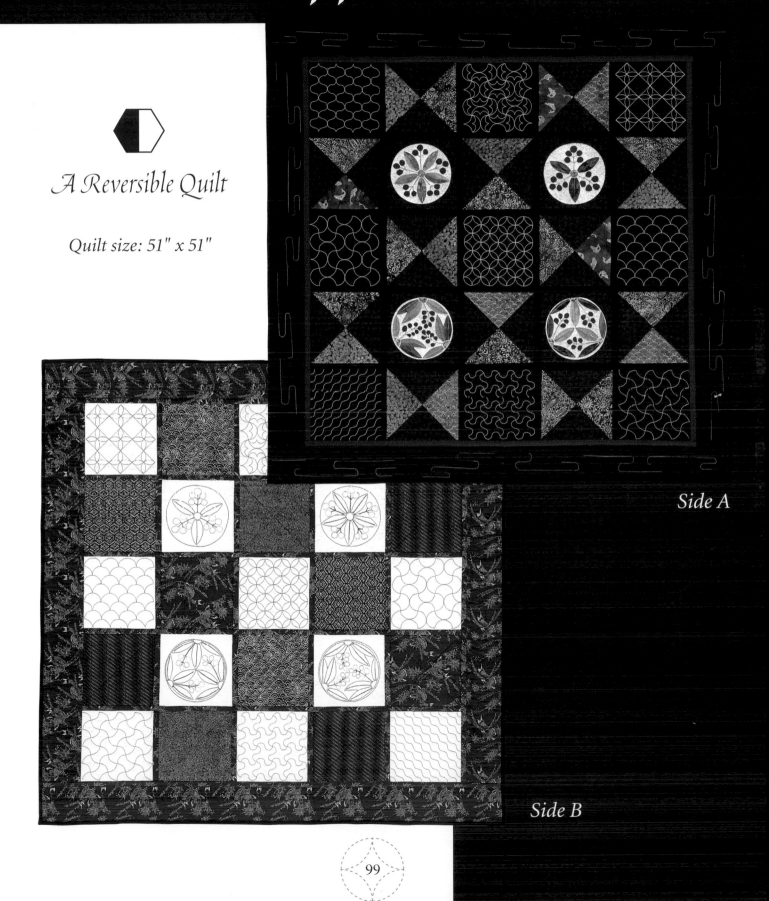

Side A

Side B

When the time came to design one last quilt for this book, I went to one of my favorite sources of inspiration—Kitty Pippen's book *Quilting with Japanese Fabrics* (Martingale & Company, 2000). I have always loved her work, and this book is never far from my reach. In it she has a wonderful quilt combining hand-sashiko patterns and family crests (on page 17). This smaller version of her quilt is offered as a thank-you for her inspirational book.

While searching for a crest to work with, I came across Nandin, a crest named after nandina, which is an evergreen shrub that is thought to be a charm against evil or misfortune. Apparently the wood is used to make chopsticks and its red berries are often used in flower arrangements on New Year's Day. One Web site described it as an herbal medicine for coughs but also warned: "Be paralyzed your breath or nerve, if mistake in the way to use or volume." Please be assured that nothing will be paralyzed if you make this quilt, except perhaps your index finger after turning under the seam allowances on the little red berries.

To make the construction of this quilt easier, I made the blocks reversible. Whenever I use the technique, I can't resist having some fun on the reverse side even though I intend the front part to be the one displayed. Create your own reversible version, or just use muslin on the back.

Materials

Yardage is based on 42"-wide fabric.

Side A

⅞ yard of navy blue fabric for sashiko blocks

⅞ yard of navy blue fabric for border

¾ yard *total* of assorted light blue prints for pieced blocks

¾ yard *total* of assorted dark blue prints for pieced blocks

⅜ yard of dark blue fabric for appliqué blocks

⅜ yard of light blue fabric for appliqué backgrounds

Assorted red and green scraps for leaves and berries

Side B

1¼ yards *total* of assorted white-on-white prints

⅞ yard *total* of assorted navy blue prints

⅞ yard of navy blue fabric for border

OR 2⅞ yards of fabric for backing (if you are using one fabric or muslin for side B)

Basic Sashing*

Side A:

 ⅓ yard of red for 1¾"-wide strips

 ½ yard of navy blue for 1¾"-wide strips

Side B:

 ⅝ yard of navy blue for 1⅛"-wide strips

Basic Binding

⅝ yard of navy blue

Reversible Binding

¼ yard for 1⅛"-wide strips

⅜ yard for 1¾"-wide strips

Batting and Supplies

1¼ yards of 96"-wide batting (I used Hobbs Heirloom Fusible Cotton Batting)

Freezer paper

Compass for drawing a circle with a 3½" radius

I used two different fabrics for sashing on side A. You'll need 5 strips of red sashing fabric and 9 strips of navy blue sashing fabric.

Cutting

From the dark blue fabric for appliqué blocks, cut:
4 squares, 9" x 9"

From the light blue fabric for appliqué backgrounds, cut:
4 squares, 8" x 8"

From the backing, cut:
13 squares, 9" x 9", from the white-on-white prints
12 squares, 9" x 9", from the navy blue prints
 OR 25 squares, 9" x 9", from the backing fabric

From the batting, cut:
25 squares, 9" x 9"
2 strips, 5" x 42½"
2 strips, 5" x 51¾"

From the assorted light blue prints, cut:
6 squares, 9½" x 9½"; cut each square twice
 diagonally to yield 24 triangles

From the assorted dark blue prints, cut:
6 squares, 9½" x 9½"; cut each square twice
 diagonally to yield 24 triangles

From the navy blue fabric for sashiko blocks, cut:
9 squares, 9" x 9"

From each of the border fabrics (sides A and B), cut:
5 strips, 5" x 42"

The first thing I did after cutting the fabrics for this quilt was to place the white-on-white and navy blue backing squares on my design wall. I wanted a simple checkerboard from a variety of fabrics so I spent a few minutes arranging them in a pleasing way. Then as I constructed the blocks for the front of the quilt, I just placed them on top of the appropriate backing square. That way I knew which backing square was supposed to be sewn to which appliquéd or pieced block without having to do any further checking.

Appliquéd Blocks

1. Draw a circle with a radius of 3½" onto a 9" square of freezer paper. Referring to "Circular Framing" on page 24, prepare four frames using the 9" dark blue squares.

2. Referring to "Machine Appliqué" on page 22 or using your own appliqué method, appliqué the frames onto the light blue 8" squares.

3. Trace onto freezer paper and cut out the pattern pieces on pages 103–104 for each of the four blocks. It's a good idea to keep the leaves and berries for each block in separate plastic bags to keep them together. Don't worry if your berries aren't all the same size and shape. Remember Mother Nature doesn't make perfectly round berries, and she gets away with it.

 Note: Do not trace the leaf veins onto the freezer paper; you'll be tracing them onto the fabric later in preparation for machine quilting. Please note on Block C that the two leaves that appear to be overlapping were appliquéd as one piece; the "edge" of the leaf is created by the quilting stitches.

4. Referring to "Invisible Machine Appliqué" on page 24 or using your favorite appliqué technique, appliqué the four Nandin designs onto the prepared blocks.

5. Trace the stems onto the background and the veins onto the leaves in preparation for quilting.

6. Referring to the photograph on page 99, place the appliquéd blocks on the appropriate backing square on your design wall.

7. Remove one of the layered blocks from your design wall. Place the backing square wrong side up, add the batting square, and place the appliqué block on top. Baste or fuse the layers together and quilt. Stitch in the ditch around the leaves and the framing circle with pale blue 60/2 cotton in the needle and navy blue Jeans Stitch in the bobbin. I added the stems and the veins with a free-motion narrow zigzag stitch, using variegated thread in both the needle and bobbin, which made the stems look more natural.

8. Repeat step 7 for each of the remaining appliqué blocks. Trim the blocks to 8½" x 8½" and return them to your design wall.

Pieced Blocks

1. Referring to the photo on page 99, arrange the light blue and dark blue triangles on your design wall.
2. Take the triangles down in pairs and sew them together; press the seams toward the dark print and return the pairs to the design wall. Do not sew the pairs together yet.

Sew light and dark triangles together in pairs.

3. Remove two pairs of pieced triangles and the appropriate backing square. Place the 9" backing square wrong side up on your work surface and cover it with a 9" batting square.
4. Place the first triangle unit right side up on the backing and batting, making sure that the long side of the triangle is ¼" beyond an imaginary diagonal line running from corner to corner on the block. Place the second triangle unit right side down (so the two triangle units are right sides together) on top of the first one, lining up the center seams, and pin or fuse to the batting and backing.

Blue square (wrong side up) → · Batting

Place one triangle unit right side up on batting square.

Place second triangle unit right side down on first triangle unit. Pin.

5. Using a scant ¼" seam, sew both triangles to the batting and backing. Flip and press lightly, then quilt in the ditch on the other seam. This will result in a quilted X on the reverse side of the block.

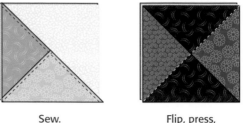

Sew. · Flip, press, and quilt in the ditch.

6. Trim the block to 8½" x 8½" and return it to the design wall.
7. Repeat steps 3–6 for the remaining 11 pieced blocks.

Sashiko Blocks and Border

You'll recognize the many variations of Seven Treasures of Buddha in the patterns I used for these blocks.

1. Referring to "Marking" on page 11, mark the sashiko designs onto the 9" navy blue squares using the patterns on pages 104–110. Arrange them on your design wall.
2. Layer each marked square with the corresponding backing square and batting. Referring to "The Ins and Outs of Stitching" on page 17, stitch the designs with a decorative thread in both the needle and the bobbin. I used white YLI Jeans Stitch in the needle and navy blue 50/3 cotton thread in the bobbin.
3. Trim each block to 8½" x 8½" and return the blocks to your design wall.
4. Referring to "Basic Borders" on page 28, use the 5"-wide border strips to make the borders. Quilt random wavy lines on the borders.

Assembly

1. Referring to "Basic Sashing" on page 20, sew the blocks together in rows of five as arranged on the design wall.
2. Sew the rows together with sashing strips.
3. Referring to "Borders with a Contrasting Inner Border" on page 28, add borders to the quilt.
4. Referring to "Basic Binding" on page 29 or "Reversible Binding" on page 31, bind the quilt.

Appliqué patterns

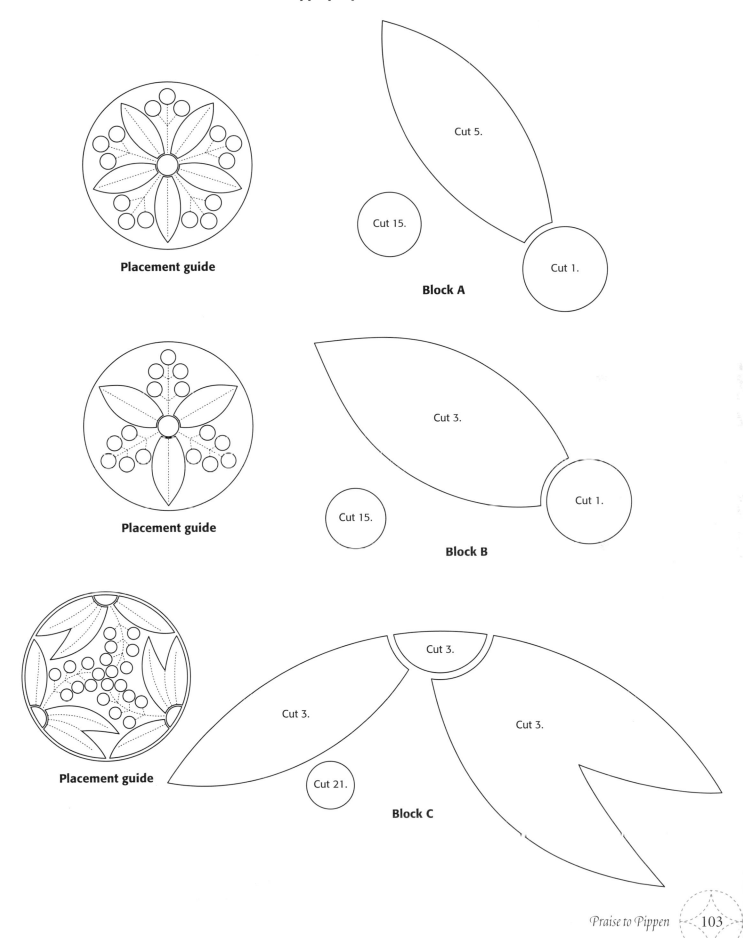

Placement guide

Cut 5.

Cut 15.

Cut 1.

Block A

Placement guide

Cut 3.

Cut 15.

Cut 1.

Block B

Placement guide

Cut 3.

Cut 3.

Cut 3.

Cut 21.

Block C

Cut 3.

Cut 3 and
3 reversed.

Cut 15.

Cut 3.

**Block D
Appliqué patterns**

Placement guide

Grid: ½"
Motif: 2"

¼ sashiko pattern

Grid: ½"
Motif: 2"

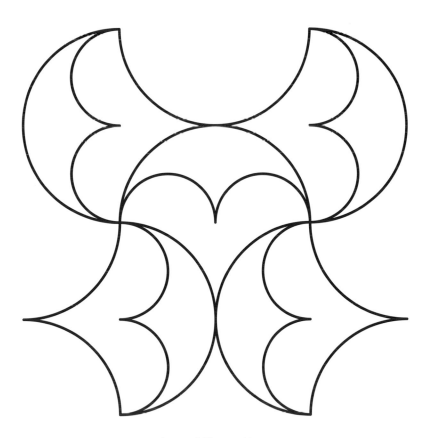

¼ sashiko pattern

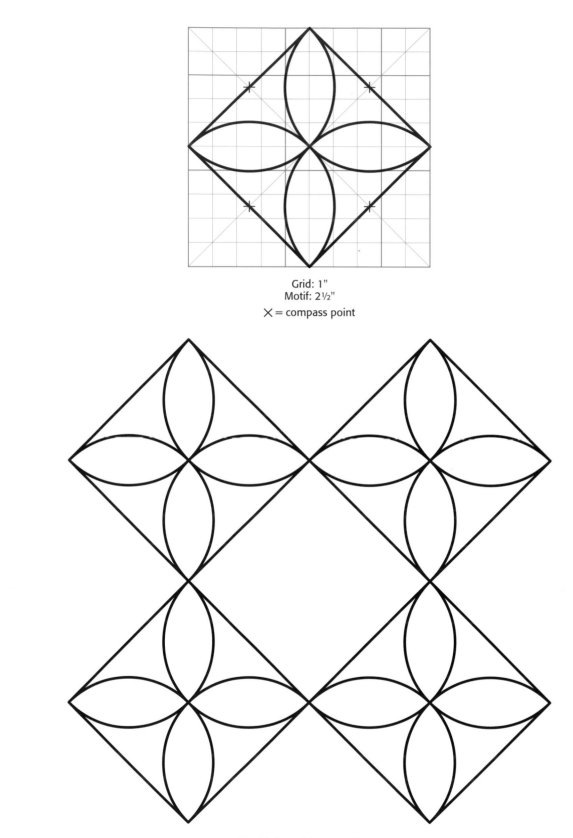

Grid: 1"
Motif: 2½"
X = compass point

Partial sashiko pattern

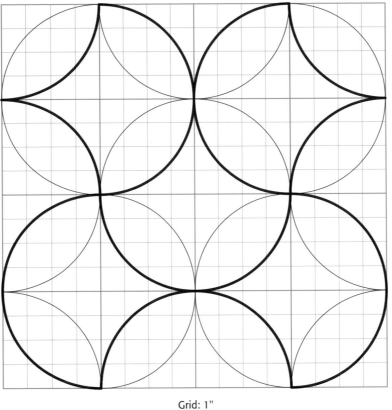

Grid: 1"
Motif: 2"

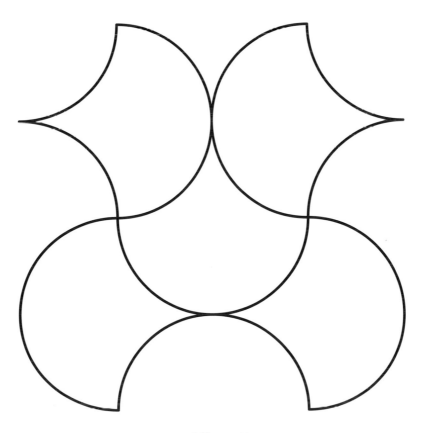

¼ sashiko pattern

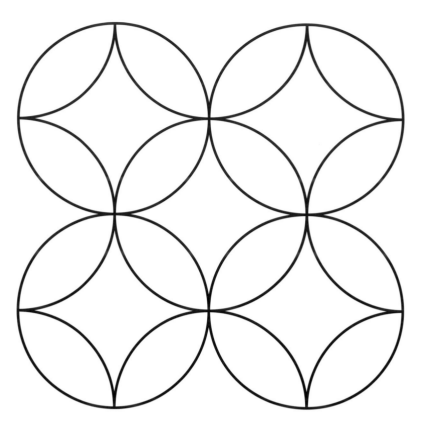

¼ sashiko pattern

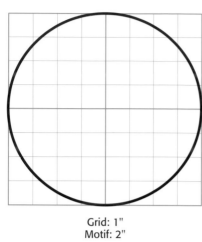

Grid: 1"
Motif: 2"

¼ sashiko pattern

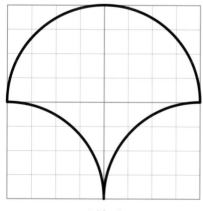

Grid: 1"
Motif: 2"

Grid: ½"

¼ sashiko pattern

Grid: ¹⁄₁₀"
Motif: 2⁴⁄₁₀"

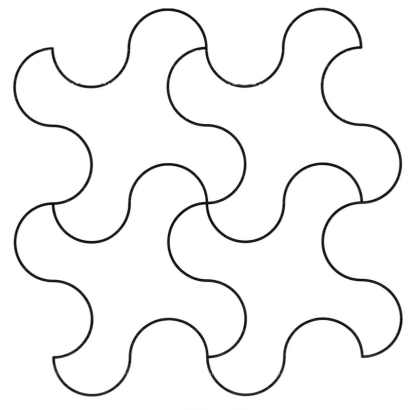

¼ sashiko pattern

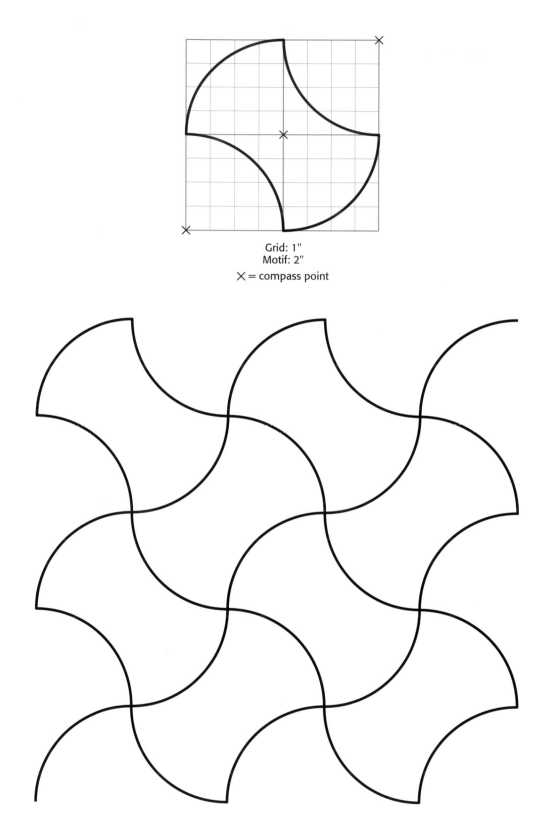

Grid: 1"
Motif: 2"
✕ = compass point

¼ sashiko pattern

Resources

Bernina
www.bernina.com
Sewing machines and specialty feet

Clover Needlecraft, Inc.
www.clover-usa.com
White marking pen #517 (fine)

Karen Combs
www.karencombs.com
Isometric graph paper

Dover Publications
store.doverpublications.com
Traditional Japanese Family Crests for Artists and Craftspeople *by Isao Honda. I like this publication because it provides English translations for the names of the crests. Also, it groups the pattern variations together.* Japanese Design Motifs: 4,260 Illustrations of Japanese Crests *compiled by the Matsuya Piece-Goods Store, translated by Fumie Adachi. This is by far the most extensive collection of crests available, but some of the pattern variations are so similar they are hard to tell apart.*

The Electric Quilt Company
www.electricquilt.com
Blending Photos with Fabric *by Mary Ellen Kranz and Cheryl Hayes;* EQ5 Drawing: Exercises in Block Design *by Patti R. Anderson*

EZ Quilting
www.ezquilt.com
Quickline II ruler

Lynell Harlow, Dreamweaver Stencils
www.dreamweaverstencils.com
Brass stencils, oil-paint sticks, and brushes

Hobbs Bonded Fibers
www.hobbsbondedfibers.com
Batting

Martingale & Company
www.martingale-pub.com
Quilting with Japanese Fabrics *by Kitty Pippen;* Machine Quilting Made Easy *by Maurine Noble;* Reversible Quilts *by Sharon Pederson;* More Reversible Quilts *by Sharon Pederson*

Kaz McAuliffe, Designs in Stitches
www.designsinstitches.com
Digitized sashiko designs for embroidery machines

Jackie Robinson, Animas Quilts Publishing
www.animas.com
Binding miter tool

StenSource International, Inc.
www.stensource.com
800-642-9293
Stencils

Laura Wasilowski, Artfabrik
www.artfabrik.com
Hand-dyed fabric and thread

YLI Corporation
www.ylicorp.com
Jeans Stitch thread

About the Author

In high school, Sharon's aptitude tests pegged her as "mechanical." Images of sliding under a car with a wrench in her hand and grease in her hair flashed through her mind; she quickly enrolled in all the nonmechanical courses she could find. Little did she know that she just had to find the right kind of machine to realize her mechanical potential.

Her motto is that if you can sew it by hand, you can sew it by machine, and you should have fun doing it. This love affair with sewing machines is an ongoing one, and she is never happier than when she is sitting at her beloved Bernina.

Teaching others to love using their machines is another thing Sharon enjoys, and a large part of her life is now spent on the road traveling from one quilting event to another. The publication of her two previous books, *Reversible Quilts* and *More Reversible Quilts* (both published by Martingale & Company), has made sure she is on the road a lot.

When not sewing or traveling to teach, Sharon enjoys cooking, reading, long walks on the beach, and movies.

She and her husband are still living happily ever after in a little house in the woods with their very old cat, Hornby, who is not only neurotic but also senile.

Sharon invites you to visit her Web site at www.sharonquilts.com.